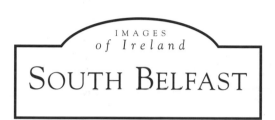

IMAGES
of Ireland

SOUTH BELFAST

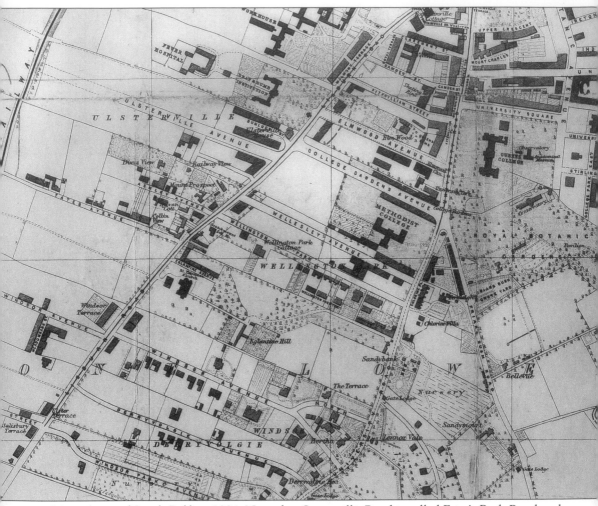

Map of part of South Belfast, 1884. Note that Stranmillis Road is called Friar's Bush Road and that University Road extends into what is now called Malone Road.

IMAGES
of Ireland

SOUTH BELFAST

Compiled by
George E. Templeton
Captions by
Norman Weatherall

GILL & MACMILLAN

Published in Ireland by
Gill & Macmillan Ltd
Goldenbridge, Dublin 8
with associated companies throughout the world
Copyright © South Belfast Historical Society, 1998

0 7171 2848 2

Typesetting and origination by
Tempus Publishing Limited
Printed in Great Britain by
Midway Clark Printing, Wiltshire

Also published in the *Images of Ireland* series:
Banbridge (Angela Dillon)
Dungannon (Felix Hagan)
East Belfast (Keith Haines)
Enniscorthy (Dan Walsh)
Tralee (Michael Diggin)

Contents

Acknowledgements

The South Belfast Historical Society wishes everyone who has helped in any way to know that their help has been invaluable in the compilation of this book.

Particular credit has to be given to Norman Weatherall from the Society who wrote all the captions (except where noted to the contrary) using the information supplied, together with his considerable knowledge of the area and its architecture. Special thanks also are due to James O'Hagan, whose grasp of the history of the Cromac area is unparalleled.

Many individuals have provided photographs and information and mention must be made of the following: Mr J.R.H. Agnew, Mr G. Barclay, Sister Breda O'Connell, Mr B.C. Boyle, Mr R. Brown, Sister Brigid Keane, Mr R. Corry, Mr D. Edmonds BEM, Mr H. Hall, Miss L. Henry, Miss G. Jenkins, Mr E. Jones, Mr R. Johnson, Mr and Mrs P. Lantin, Mr J. Lee, Mr D. Moore, Mr J. Moreland FBIPP, Miss J. Murphy, Mr T. McAlister, Monsignor A. McAuley, Mr A.J. McCullough, Mr E. Martin, Mr S. Matchett FRPS, Mr W.H. Montgomery, Miss J. Murphy, Mr J.F. O'Sullivan OBE FRCOG, the Revd G. O'Hanlon, Mr C.F.A. Quigley, Mr W. Robb MBE, Mr R. Ross, the Revd J.C.T. Skillen, Mr W. Smith, Mr and Mrs G. Stelfox, Mr and Mrs L. Stewart, Mr R.G. Trouton, Mr W. Wallace, Mr L.D. Williams, Mr M. Williamson.

In addition, many organizations extended full co-operation and made detailed information available to us. Special mention must be made of Queen's University and particularly of Mr Ivan Strahan, who provided the photographs of the University and the former College used in the book.

We are also most grateful to the Royal National Institute for Deaf People, the Royal Ulster Constabulary Museum, the Irish Rugby Football Union (Ulster Branch, Ravenhill), Ulster Folk and Transport Museum, Ulster Museum, Public Record Office for Northern Ireland, Ormeau Bakery, Northern Ireland Electricity, Inchmarlo, Lilliput (Dunmurry) Ltd, Belfast Central Library, Loyal Orange Lodge No. 819, Environment and Heritage Service, Ulster Hall.

Lastly, mention has to be made of daughters Alison and Pauline for their assistance when things went wrong with the computer.

The hope is that those who read this book will find it both interesting and informative and will get as much enjoyment from it as did those who put it together.

George E. Templeton

Foreword

Having viewed this collection of photographs, some old and some not so old, I knew it was going to be a pleasure to write a preface to this publication. The book covers a wide spectrum of life in picture form, from Highways, Byways and Waterways to Street Life, Business, Health and Welfare, Sport and Recreation, Youth, Education, Religion and Wartime.

The time span covered is somewhere in the region of 120 years. The older the subject, the greater is the difficulty in obtaining a good specimen to reproduce on paper. Photography was only discovered as a new art form in 1839 and for many years afterwards a camera would have been a luxury few could afford. As you go through these pages you will not only be struck by the changes in lifestyles but by the ever-increasing speed with which the changes have taken place. The pictures convey very successfully the kaleidoscope of life. The rural lifestyle hinted at by the activities on the Lagan canal, first opened during the 1760s, contrasts with the era of leafy suburban residences, which were later swallowed up by Belfast's population explosion of the late nineteenth century.

Both World Wars accelerated change and old ways vanished for ever. The reader might be forgiven for wondering just where it is all taking us. We are so much better off materially than we used to be but we must wonder where all that time has gone that we used to spend 'smelling the roses'. South Belfast shared in these momentous changes.

As chairman of the South Belfast Historical Society I take great pleasure in commending this book to the reader, not only as a pictorial account of days past but as a record to be retained for future reference. Who knows? It may prompt a wistful sigh for places remembered and now gone, or even an odd tear for those known but since departed. I should like to record my thanks to all members of our Society and our friends and well-wishers who in any way contributed to compiling this publication. A special word of thanks is due to the Society's secretary, George Templeton, for the amount of time, effort and enthusiasm he has so willingly devoted to the production of this book.

Roy Allen
Chairman

Introduction

By South Belfast we mean an area of the city and its suburbs fanning out from the City Hall, bounded by the Ravenhill and Donegall Roads and stretching out to Newtownbreda, Upper Malone and Finaghy.

South Belfast developed as a result of a movement of population out of the old town of Belfast, centred on the White Linen Hall, and a movement in from the countryside. In the early part of the nineteenth century the old town was becoming increasingly unattractive as a place of residence for the well off. The flooding of the Blackstaff river was a periodic problem; the arrival of business premises in, say, Donegall Place (then Linen Hall Street) was changing the character of the area. Gradually the prosperous merchants and professional classes began to move out via housing developments on Great Victoria Street and Dublin Road, through Shaftesbury Square, to attracttive new terraces, for example the Crescents (1846 and 1852) and University Square (1848-53), where Queen's College, opened in 1849, provided a focus for middle-class urban development, and further, building large houses on the Malone ridge and the Stranmillis 'plains'. Two pieces of legislation assisted: the Encumbered Estates Acts (second Act 1849) enabled land to be acquired for building in Ballynafeigh, Malone and Stranmillis; the Turnpike Abolition Act of 1857 put an end to the payment of tolls at the town's boundary, beyond which the expansion was taking place. An important contribution was made from 1872 by a tramway system offering cheap and frequent communication between the town centre and the developing suburbs. The opening of the second Ormeau Bridge in 1862 also contributed.

Rural poverty, exacerbated by the Famine and the mechanization of the textile industry, drove many from the countryside to seek a new life in the town. The railways were to play a crucial role in the process. The Ulster Railway opened its first line (to Lisburn) in 1839 and extensions to Lurgan (1841), Portadown (1842) and Armagh (1848) followed. The people the trains carried were to fill the streets of industrial housing around Belfast's three termini; work would be found in mills and factories. The growth of such areas was greatest in the last quarter of the century.

To cope with these developments, the town boundary was extended in 1854 and 1896, and regulations were laid down to control house building – the ratio of street width to house height, provision of rear access, etc. The spiritual welfare of the people was attended to by the large number of churches built, especially during the 1880s and 1890s, which represented all the main denominations; many churches also had their own day schools. Working hours for those lower down the social scale were long but there was provision made for such leisure time as they could find in the form of public parks – South Belfast is well endowed in this respect. Ormeau (1871) was the first and Botanic Gardens, Drumglass, Musgrave, Barnet's and Dixon have joined it over the years.

South Belfast grew up with two 'faces': the prosperous avenues of the Malone Road and the working-class streets of the lower Ormeau, Donegall Road etc. The Lisburn Road marks a line of division between the two: middle class on the left (avenues to the Malone Road) and on the right the 'mean' streets. There have been changes in the second half of the twentieth century. Malone's big houses are now used as institutional or business premises; redevelopment has cleared away nineteenth-century housing in Cromac, the Donegall Pass area and in Ballynafeigh. The 'Markets' have spread into the lower Ormeau. But, despite change, South Belfast remains dynnamic. Perhaps its most urgent problem is what to do about the traffic as new housing estates draw people even further out of town and lines of communication grow longer.

Norman Weatherall

One
Highways, Byways and Waterways

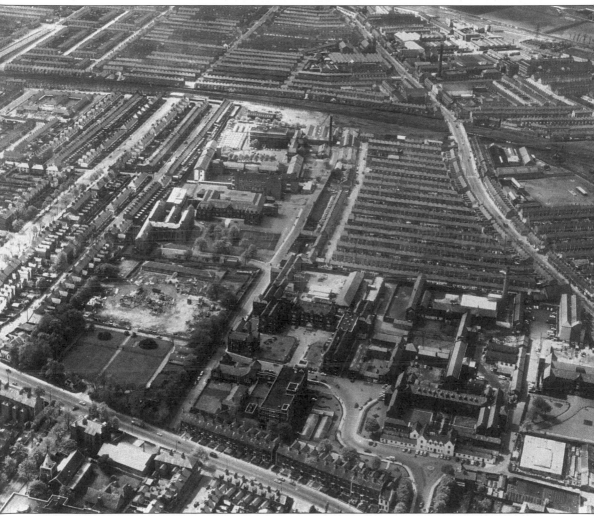

An aerial view of South Belfast, c. 1964. The Lisburn Road cuts across the lower left-hand corner, passing the site of the recently demolished Deaf and Dumb Institute on which will rise the new Queen's University Medical Biology block; the construction of the City Hospital tower has yet to begin. The Donegall Road forms a triangle with the upper right-hand corner of the photograph.

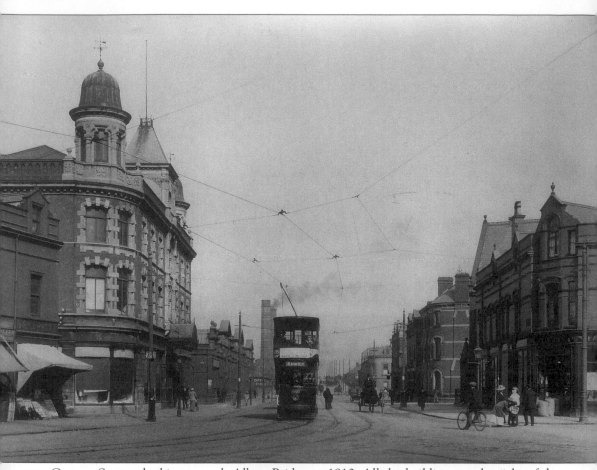

Cromac Square, looking towards Albert Bridge, *c*. 1910. All the buildings on the right of the photograph have been replaced by modern housing; on the left the lower two storeys of the tall building remain along with, beyond it, St George's Market, which is presently being restored. The tall chimneys of the power station have also gone. The tram is an open-ended 'Standard Red' of the type built in Sandy Row between 1908 and 1913. (By permission of Ulster Folk and Transport Museum, WAG 3756)

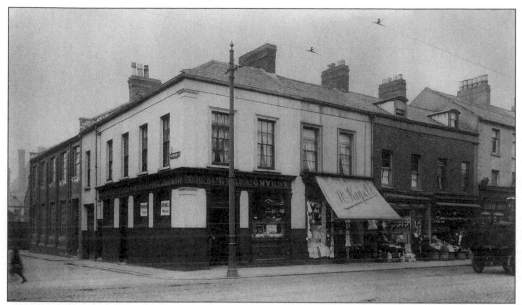

Cromac Street, *c.* 1912. Laid out in the 1860s, Cromac Street was an important link between the city centre and the suburbs at Ormeau. The Cromac spring under it supplied Corry's mineral water manufacturers. The street contained nine public houses, the Irish Temperance League's coffee stand at 23-25, and the premises of James Lundy who boasted that he sold everything from a donkey to a four-engined bomber. (J.O'Hagan) (By permission of Ulster Museum, H 10/29/102)

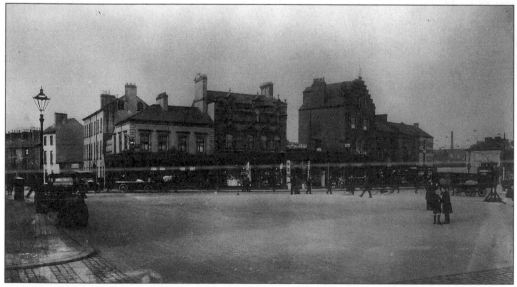

Cromac Square at the city end of Cromac Street, 1932. The Square was once an interesting area with its links with St George's Market and the Albert Bridge. In the photograph are the licensed premises of Barney McCoy and some early nineteenth-century housing in Hamilton Street, called after James Hamilton, a prominent merchant who lived at No. 3, whose family became the Hamiltons of Barons Court, Co. Tyrone. The hoardings, right, hide the site on which Telephone House (1932-5) was rising and where Robert Wilson's bakery once stood (see p. 46). (J. O'Hagan) (By permission of Ulster Museum, H 10/29/83)

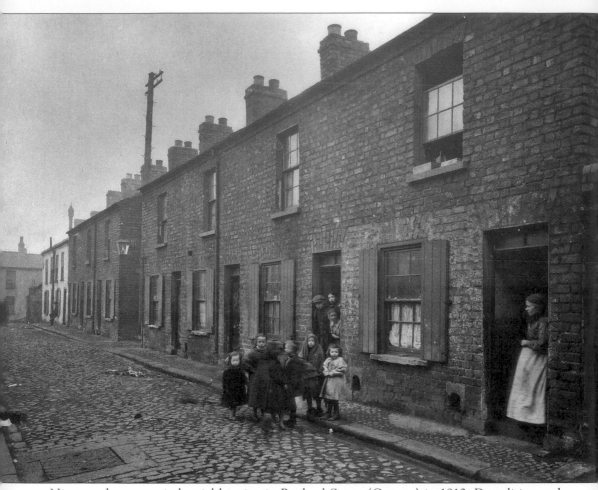

Nineteenth-century industrial housing in Raphael Street (Cromac) in 1912. Demolition and replacement as recommended by various reports could not keep pace with demand; the Second World War stopped house-building altogether. Wartime destruction further reduced available accommodation. The work of the Housing Trust and its successor, the Housing Executive, was to bring about a transformation of many areas of the city as well as creating new housing estates on green-field sites. Note the bare feet of the children, the little girl 'shawlie' and the boot scrapers beside the front doors. The 1912 directory lists nineteen dwellings, the householders of four of which were women; five male householders are listed as labourers. (By permission of Ulster Museum, W 10/29/42)

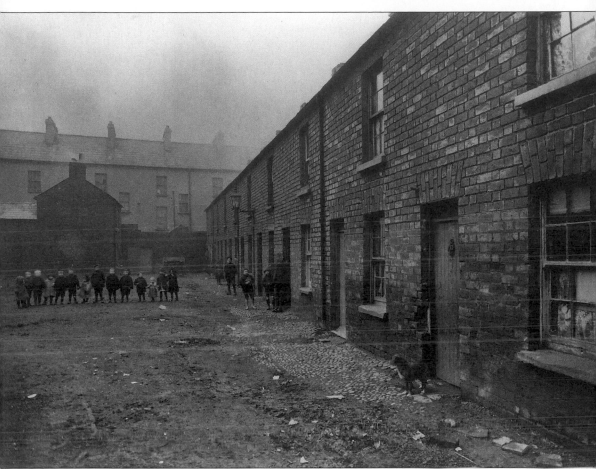

Riley's Court (Cromac), 1912. Belfast's poorest lived in slum conditions in courts and entries tucked away behind more prosperous housing. Poverty caused by low wages, unemployment and trade depression forced people to crowd together in cramped, insanitary dwellings. Note the unpaved court: a bye-law of 1865 required all streets to be paved and sewered; presumably courts such as this were not covered by the legislation. The 1906 directory baldly states 'eleven small houses'; tenant's names are not given. (By permission of Ulster Museum, W 10/29/44)

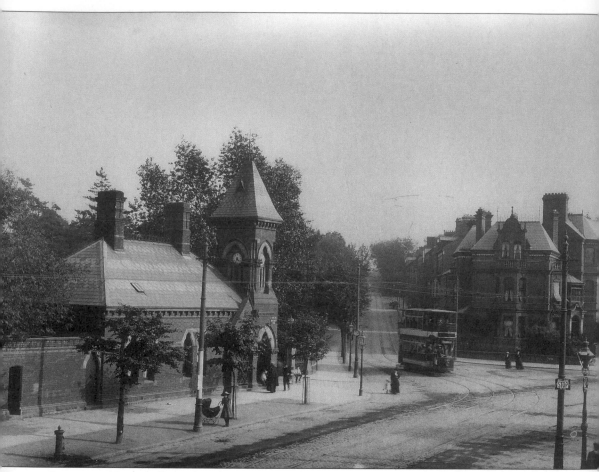

Junction of Stranmillis and Malone Roads, at the entrance to Botanic Gardens. The Venetian Gothic gatehouse (demolished 1965) and gate piers were designed by William Batt around 1880. The Botanic Gardens (Royal from 1840) were established on their present site in 1829 by the Belfast Botanic and Horticultural Society. Queen Victoria visited in 1845 and the Gardens, a private concern not generally open free to the public until 1895, hosted large-scale events such as a monster religious revival meeting in 1859 and an anti-Home Rule demonstration in 1892. The first tram route in Belfast (using horse-drawn vehicles) ran between Castle Place and Botanic Gardens in 1872. (By permission of Ulster Folk and Transport Museum, WAG 3763)

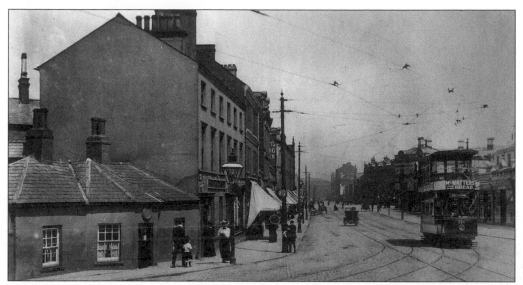

The tollhouse, left, and Bradbury Place, c. 1912. The tollgate originally stood at the junction of Sandy Row and Malone Road at what is now Fountainville Avenue. When the Lisburn Road was constructed, from 1817, the gate was moved to the head of Bradbury Place so that tolls could be levied on users of both roads. Only Royal Mail vehicles were exempted: whether Queen Victoria paid up on a visit to Belfast is unclear. Tolls were abolished in 1857. In its last years the redundant tollhouse was occupied by a chimney sweep. (By permission of Ulster Museum, H 10/29/78)

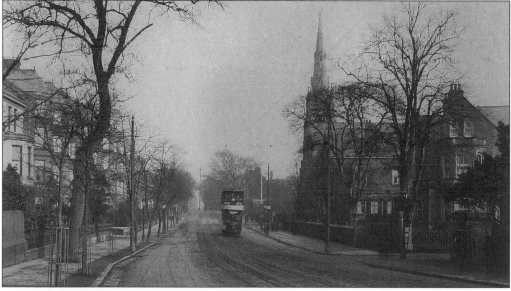

Malone Road at Lennoxvale. The Turnpike Abolition Act of 1857 assisted the movement of population outwards from the town centre. The Malone Ridge was well drained and the air pure; the old estates were broken up and villas, terraces and avenues linking the Malone and Lisburn Roads took their place. Fisherwick Presbyterian church, on the right, built between 1898 and 1901 (architect S.P. Close, builder R. Corry), reflects the movement of the upper classes to the suburbs, replacing as it did the old church in Fisherwick Place. (By permission of Ulster Folk and Transport Museum, WAG 3762)

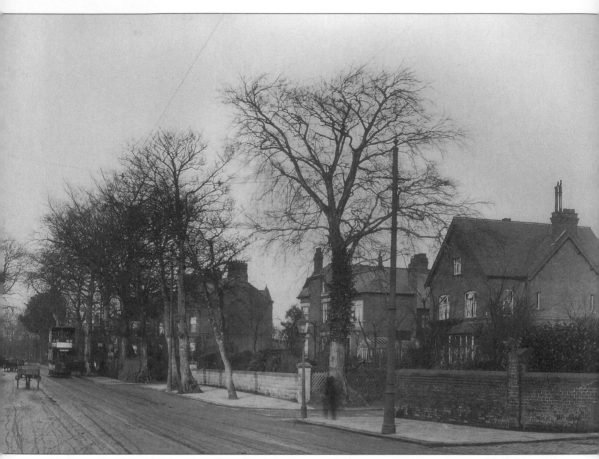

Malone Road at Malone Park. The extension of the tramway system enabled housing development to take place even further from the city centre. The line to Botanic Gardens, opened in 1872, was extended to Malone Park in 1888. In 1881 any tram journey cost twopence, but in 1892 a one penny stage was introduced and cars left at five minute intervals on the main routes. The longest one penny stage in South Belfast was at Marlborough Park, then being developed by H. and J. Martin. Trams ceased to run on the Malone and Stranmillis Roads in 1951. (By permission of Ulster Folk and Transport Museum, WAG 3796)

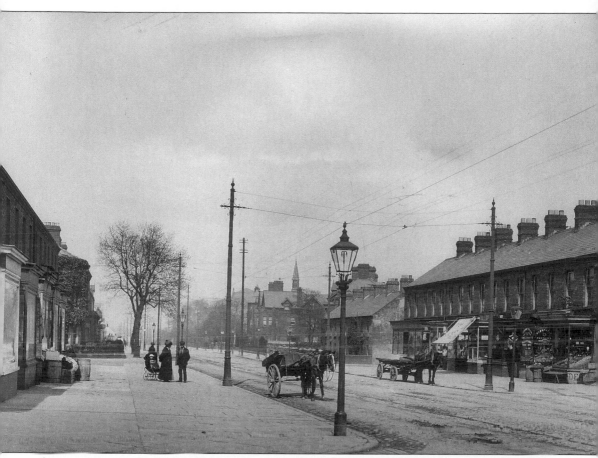

Ormeau Road, looking townwards at Somerset Street and South Parade, *c.* 1910. Some of the houses still remain on both sides of the road, though now converted to business premises; those demolished have been replaced with appropriately scaled terraced housing. The flèche that once adorned the roof of Cooke Centenary Presbyterian church pops up above the villa, now a bank, at the corner of South Parade. (By permission of Ulster Folk and Transport Museum, WAG 3811)

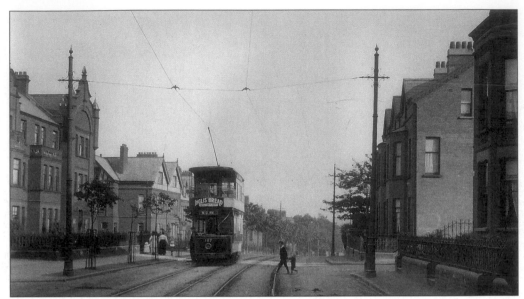

Stranmillis Road. Development took place on the Stranmillis 'plains' between the last decade of the nineteenth century and the First World War. Unlike the Malone area, Stranmillis became a grid of streets of dull terraced houses, on one side running down to the River Lagan. Conversions to commercial use have greatly altered this section of the road. 'Stranmillis' is derived from the Irish *sruthán milis*, meaning 'sweet stream'. (By permission of Ulster Folk and Transport Museum, WAG 3770)

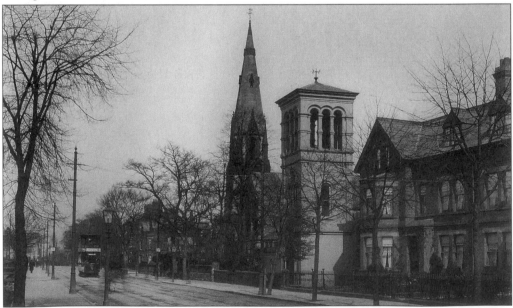

Rosetta, Ormeau Road. St John's Presbyterian church (1890-92, by Vincent Craig) and its predecessor are to the right. The Rosetta area was developed from the mid-1880s by R.J. McConnell and Co., which had taken a seventeen-acre site on which to build houses for prosperous middle-class families. H. and J. Martin also built at Rosetta and on the Ormeau Road. The extension of the tramline to Hampton Park in 1885 encouraged building in the upper Ormeau area. (By permission of Ulster Folk and Transport Museum, WAG 3773)

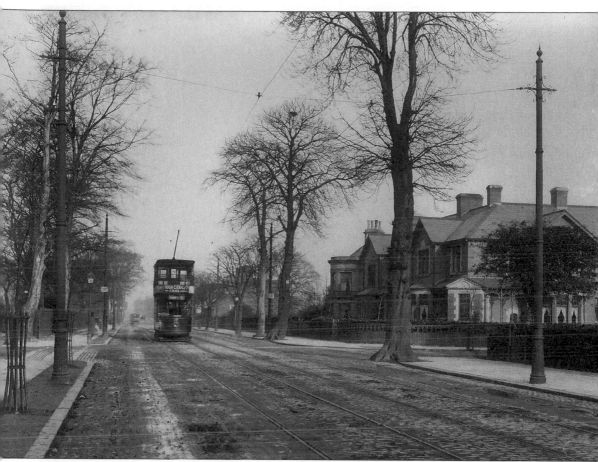

Ravenhill Road at Ravenhill Park. On the left is Ormeau Park, Belfast's first public park, acquired from the Donegall Estate in 1869 and opened in 1871. On the right, Ravenhill Park was developed by R.J. McConnell and Co. at the end of last century. After the trams (electric since 1905) were withdrawn, the lines and square-sets were lifted, the disposal of the latter causing a headache for those responsible for the roads. (By permission of Ulster Folk and Transport Museum, WAG 3757)

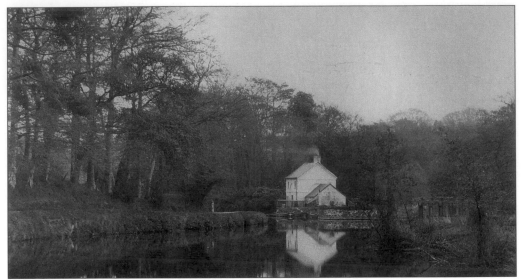

River Lagan and towpath. The lock keeper's cottage stands on an island formed by the river and the canal. It was one of a number built to a standard design in around 1760. Belvoir Park is on the right. (By permission of Ulster Folk and Transport Museum, WAG 2211)

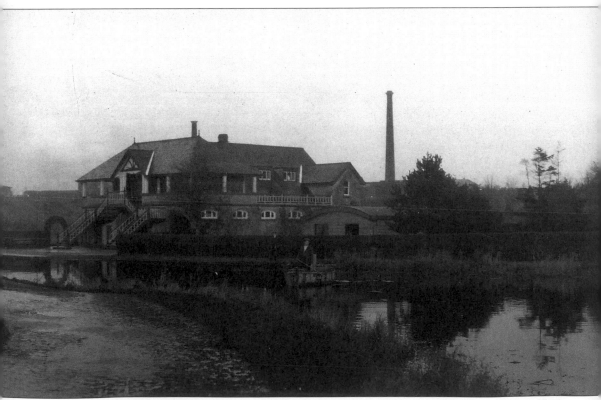

Lagan Canal, a short distance above the first locks at Stranmillis. To the left is Belfast Boat Club (founded 1898) with tennis courts behind it on the site of Molly Ward's tavern, famous in

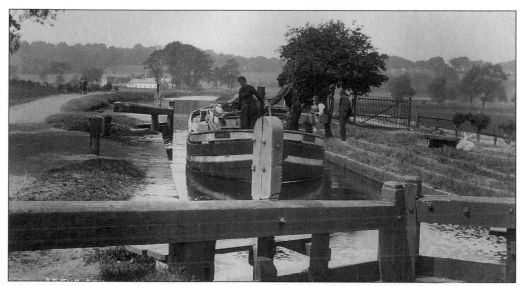

A barge leaving the third lock, McLeave's, on the Lagan canal. Ulster canals, unlike their English counterparts, did not carry passengers, concentrating instead on agricultural produce, coal and manufactured goods. The Lagan Navigation was never a satisfactory waterway at any time. The arrival of the railway rendered the canals redundant. (By permission of Ulster Folk and Transport Museum, WAG 3790)

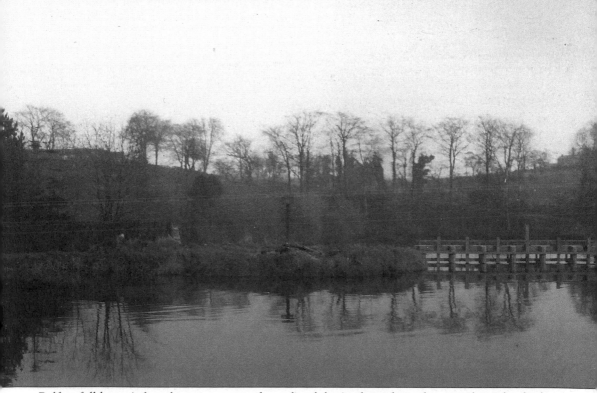

Belfast folklore. A ferry boat is crossing from the club. At the right is the weir through which the river flowed to bypass the canal. Two brickworks chimneys loom in the background.

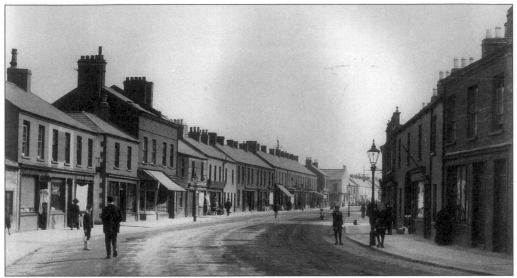

Sandy Row, in the direction of the Boyne (once Saltwater) Bridge. The name Sandy Row may refer to the geological nature of the place, as sand had been piled up by the Blackstaff river which is tidal up to the Saltwater Bridge; alternatively it takes its name from a former landlord, Alexander (Sandy) Frazer, who built a row of houses there. Most of the area has been redeveloped though some old houses remain behind new shop fronts. Industries that provided employment included brick-making, textiles (at Linfield Mill), starch works, felt works, tobacco and the railway; the tramway system had a workshop and depot in Napier Street. (By permission of Ulster Folk and Transport Museum, WAG 3821)

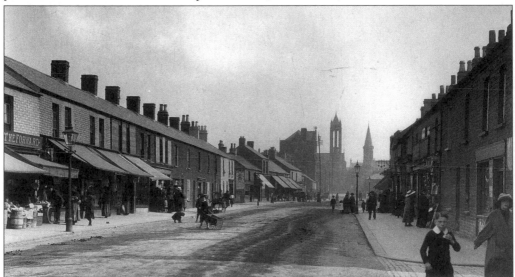

Sandy Row, looking towards the Donegall Road and the former Crescent Presbyterian church on University Road. Orange Hall (built 1909-10) is in the distance on the left. The road to Dublin left Belfast town at Millfield and passed along Sandy Row to climb the Malone Ridge at the city end of University Road where the two churches now stand. The Williamite forces would have passed this way *en route* south in 1690: the little 'park' at the end of the Lisburn Road is known as King William's, tradition having it that he made a stop there. (By permission of Ulster Folk and Transport Museum, WAG 3820)

Two
On the Streets

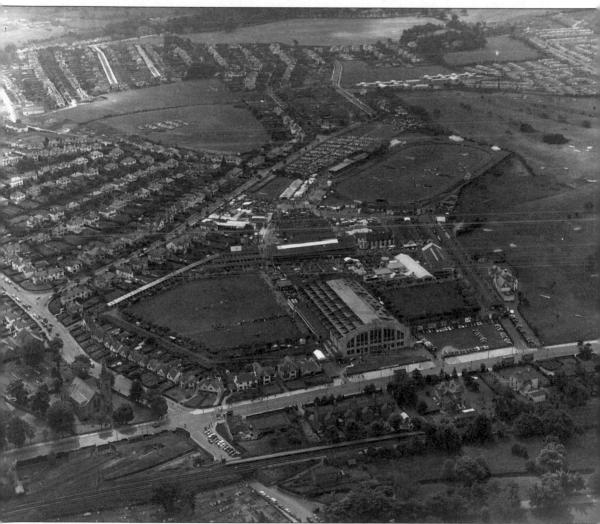

Aerial view of the Balmoral Show Grounds, headquarters of the Ulster Agricultural Society, before the addition of the new Members' Room (the 'Threepenny Bit') in 1965 and the 1981-82 re-roofing of the King's Hall. The present road alignment at Balmoral Avenue/Lisburn Road has not yet been created.

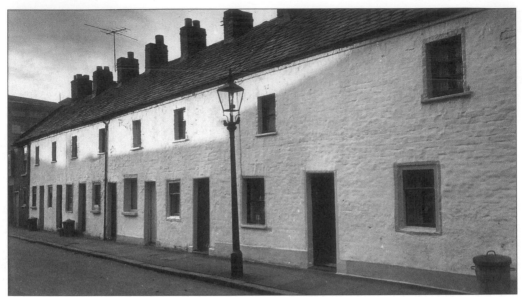

Rowland Street, off Sandy Row. Until its removal to the Ulster Folk and Transport Museum, Rowland Street, once Tea Lane, was one of the oldest streets in Belfast: it appears on the OS map of 1832, and in the Valuation of 1837 it is recorded as having twenty-two houses at 1s 2d, four at 1s 4d and six 'very small cabins' at 10d a week. While the Belfast Street Directory of 1870 gives a full list of the occupiers of these houses, the 1890 edition dismisses Rowland Street as 'several small houses'. (© Crown copyright. Reproduced with the permission of the Controller of Her Majesty's Stationery Office)

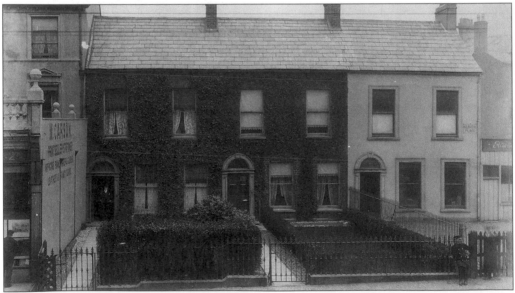

Albion Place, c. 1914. The valuation of 1837 rated these houses, such as remain now hidden behind the shops along Bradbury Place, at £10 to £13 – 'very substantial … and beautifully situated'. The yawning (bored?) individual on the right is an employee of the tramways whose task it was to change the points for trams using the Lisburn and University Roads, hence the gadget he is holding. What is the explanation for the coats hanging on the fence? (By permission of Ulster Museum, H 10/29/117)

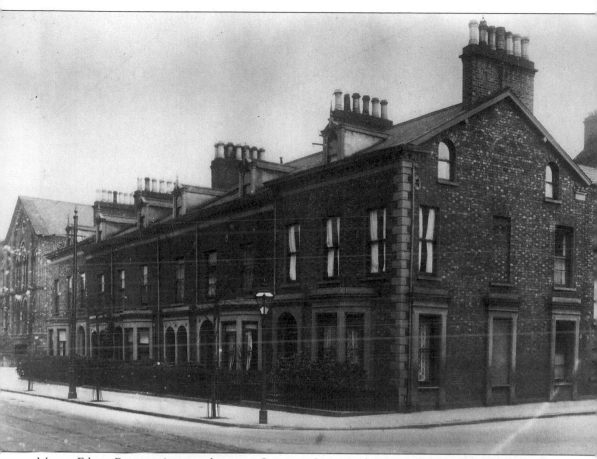

Mount Edgar, Botanic Avenue, between Cameron Street and Cromwell Road. The practice of labelling a block of houses as a terrace, as well as giving the houses street numbers, was widespread at the end of the last century and was found in streets less grand than Botanic Avenue. These houses and the Reformed Presbyterian church, left, date from the 1870s. The 1880 street directory records the occupants, from the right, as J. McGowan, linen manufacturer; W. Turnbull, cashier; A.P. Shepherd Jnr, agent; the Revd Charles Seaver, rector of St John's church, Laganbank. The church is now an entertainment spot and restaurant, the houses have been largely rebuilt as shops; only Mr Seaver's house retains any original features. (By permission of Ulster Museum, H 10/79/1)

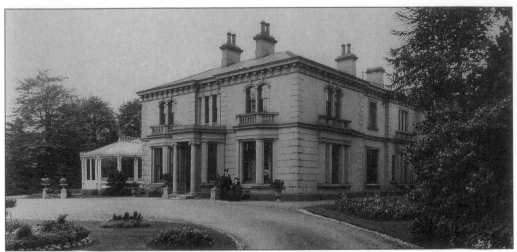

Derryvolgie House, Malone Road. The Malone ridge came to be dominated by large houses as the rich merchant classes moved out of the old town centre: Stranmillis (1857-8, for Thomas Batt, banker), Wellington Park (1853-4), Drumglass (1855, for the Musgraves, heating engineers), Thornhill (1855, for the Walkingtons, linen merchants), Derryvolgie (1857, for Forster Green, tea importer) and Rupert Lodge (1892, for Peter McAuley, solicitor). (By permission of Ulster Folk and Transport Museum, WAG 3247)

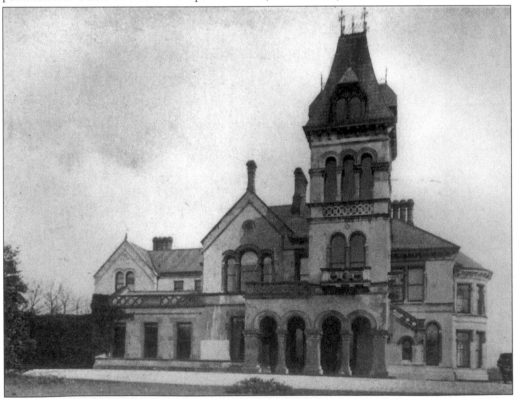

Danesfort, Malone Road: a splendid conflation of Italian, French and Tudor elements, built in 1864 by W.J. Barre for Samuel Barbour, linen merchant. It now belongs to the Northern Ireland Electricity Service, which has restored it to its former glory.

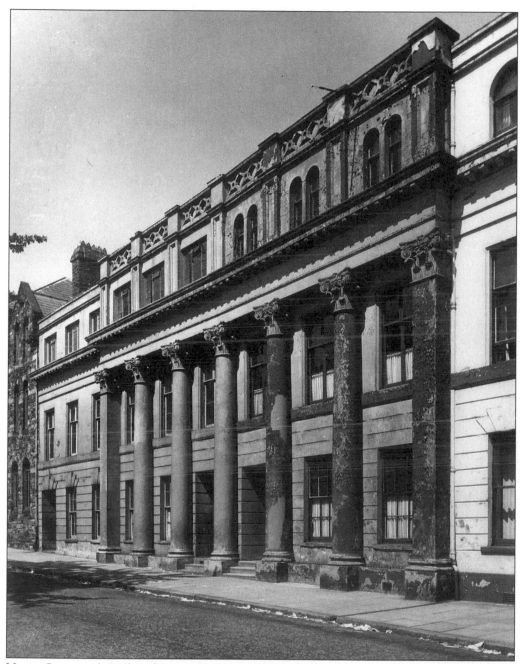

Upper Crescent (1846) and Lower Crescent (1852), seen here, are Belfast's grandest attempts to emulate similar schemes in towns such as Bath. The tall columns add distinction to the composition. The name of the architect is unknown. (© Crown copyright. Reproduced with the permission of the Controller of Her Majesty's Stationery Office)

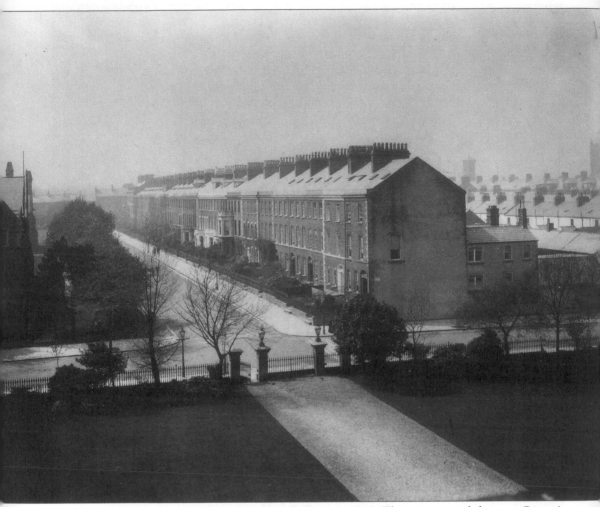

University Square viewed from Assembly's College, *c*. 1910. The area around the new Queen's College grew rapidly in the 1840s and 1850s, providing accommodation for College staff and other professionals. The Square is still one of Belfast's finest terraces. The architect is thought to have been Thomas Jackson and the terrace dates from 1848 to 1853. (By Permission of Ulster Museum, H10/79/51)

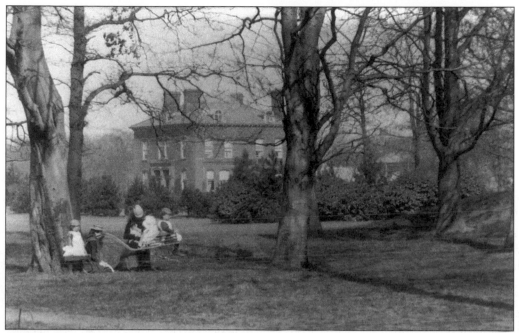

Oakleigh House, Ravenhill Road, c. 1890. Oakleigh was the official residence of the manager of the Belfast Gasworks, James Stelfox, at the time of the photograph. A family group amuses itself in the foreground. The house, used by the Royal Air Force during the Second World War, was later a school; it has since been demolished.

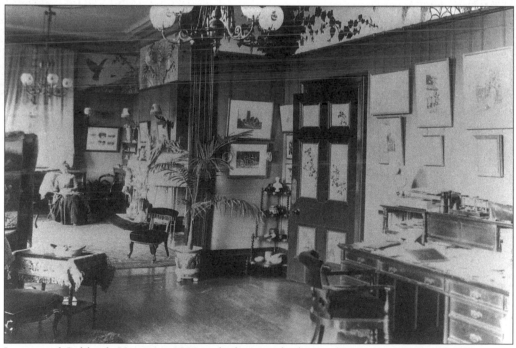

Interior of Oakleigh House, c. 1890: a fairly typical, cluttered Victorian scene. The frieze was painted by Mrs Stelfox, wife of the gas manager. She is believed to be the figure sitting in the inner room.

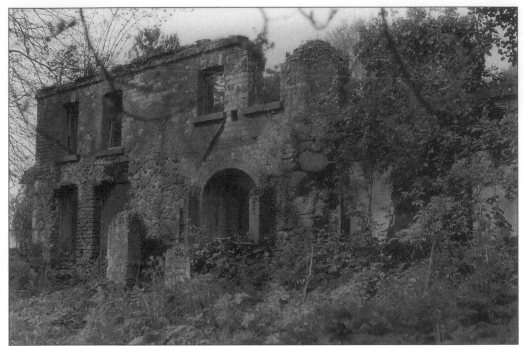

Ruins of Cranmore, Malone. Mr Eccles, the owner, invited King William III to shelter in his house from the rain when the king was passing *en route* to the Boyne in late June 1690. The house was subsequently known as Orange Grove in memory of the occasion. Later Cranmore was the home of John Templeton (1766-1825), botanist, geologist, zoologist and meteorologist. He compiled a catalogue of native plants but died before he had completed his natural history of Ireland. His collections went to the Belfast Museum of Natural History.

Old stables at Malone Presbyterian church (1898-99) where members of the congregation who arrived by carriage put up their horses during divine service. This view dates from 1977.

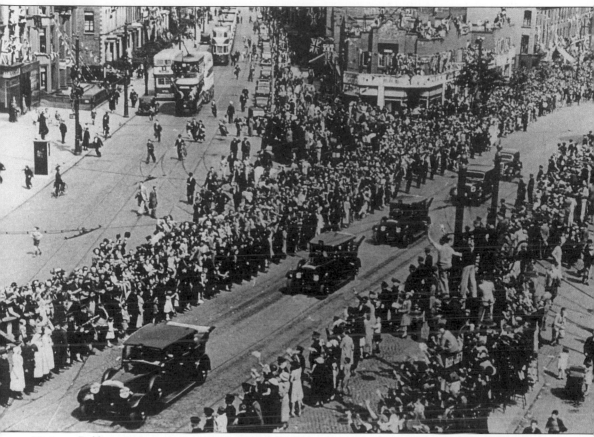

Visit to Belfast of King George VI and Queen Elizabeth after their coronation in 1937. The royal cavalcade is crossing Shaftesbury Square.

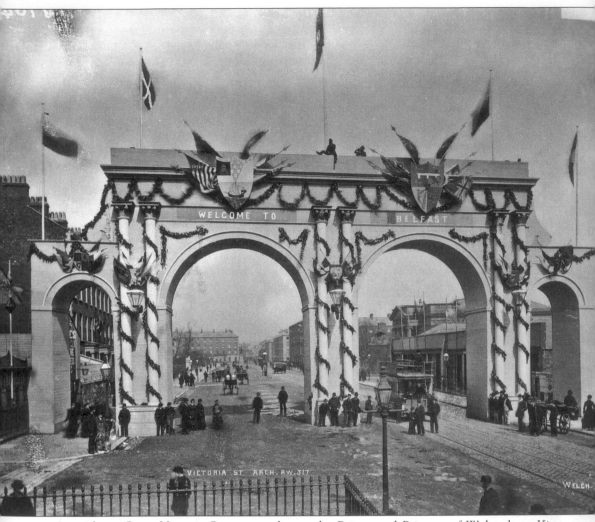

An arch on Great Victoria Street to welcome the Prince and Princess of Wales, later King Edward VII and Queen Alexandra, to Belfast in 1885. Note the horse tram, introduced in 1872, and the late Georgian terraced houses in Fisherwick Place and College Square. The classical building through the arch on the right is the old Fisherwick Presbyterian church on the corner of Howard Street. It was built in 1827, sold in 1898 and demolished to make way for Assembly Buildings. (By permission of Ulster Museum, W 10/29/14)

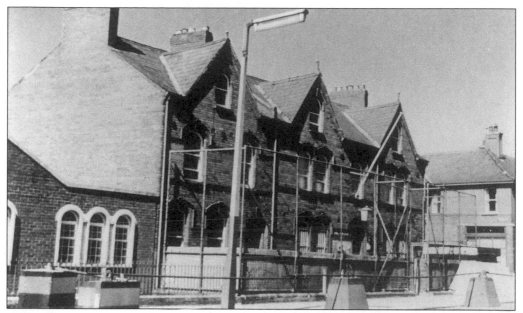

Lisburn Road police station, 1970s. The Troubles of the 1970s brought into being a new type of police station. The old ones tended to be neighboured by shops, houses or, in the case of Lisburn Road, a church. This made them vulnerable to bombers: elaborate defences could be circumvented via neighbouring premises. Old stations fell to the bombers on the Lisburn and Ormeau Roads and at Dunmurry and were replaced by huge new fortresses incorporating the latest thinking in security.

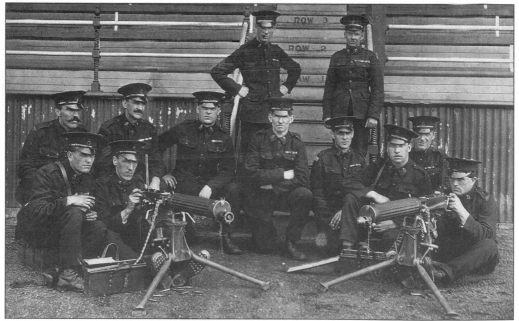

B Specials, c. 1921. The machine guns are a reminder that the Specials were recruited to help defend the new Ulster state. Formed in October 1920, the force was meant to be drawn from both sides of the community, a hope that was not to be realized. The Specials were disbanded in 1970.

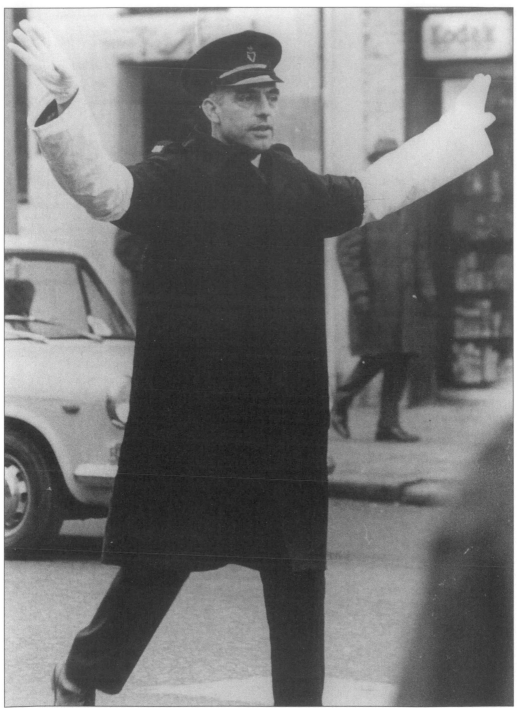

Constable Harry White, a familiar figure at Bradbury Place/Shaftesbury Square in the 1960s, controlled a seven-road junction where it was reckoned 4,000 vehicles passed every hour. His dedication, efficiency and popularity with the public earned him a BEM in the 1971 New Year's Honours after ten years' service. His 'customers' showed their appreciation by leaving gifts for him at Christmas.

Dunmurry RUC station, *c.* 1935, when the bicycle was the bobby's chief means of transport. Not an armoured car in sight! The RIC crest above the door was replaced by a station lamp around 1939.

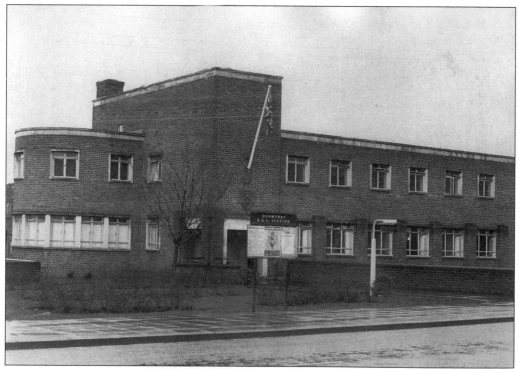

As a result of post-Second World War housing developments, Dunmurry ceased to be a village. The larger station of the 1950s reflects this change in the area covered from Dunmurry, as well as the greater complexity of modern policing. This building was severely damaged by an IRA bomb in the 1970s.

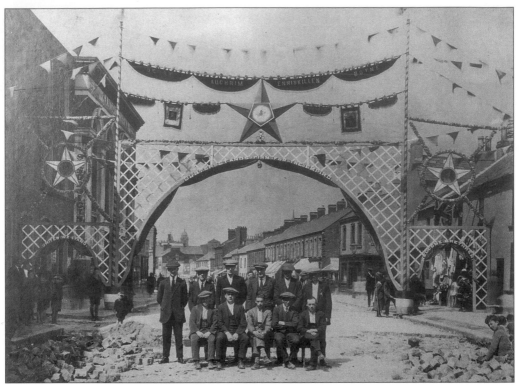

The first Orange Arch to be erected in Sandy Row, 1920 or 1921. Frank Reynolds, the arch-builder, is fifth from left, standing. The Sandro cinema can be seen to the left.

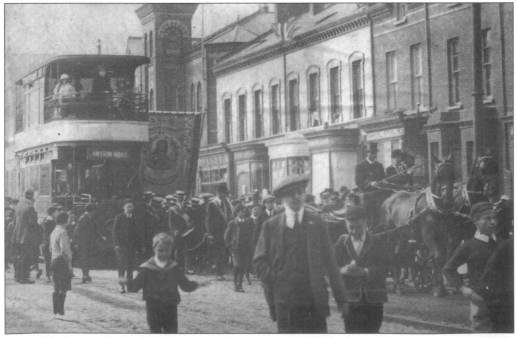

LOL 454, Stranmillis Volunteers, leads the district on 12 July from Ballynafeigh Orange Hall, c. 1920. Note the horse-drawn brougham used to convey older senior officers.

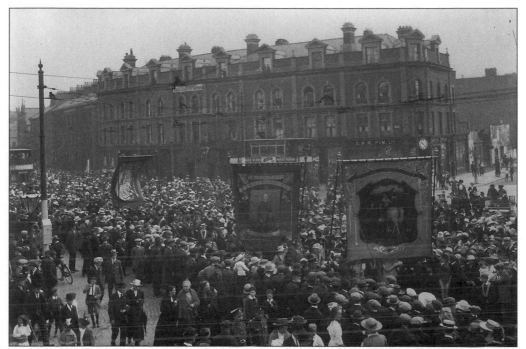

A Twelfth of July procession passing through Shaftesbury Square. The banner in the centre belongs to the Kane Memorial Temperance Independent Lodge. The Revd Dr Kane (1841-1898) was rector of Christ Church in Durham Street; a strong opponent of Home Rule but a nationalist in economic matters, he was a leading figure in the Orange Order and a Gaelic speaker at a time before the language question became political. The names on the shops would date the occasion to the early 1920s. Messrs Pim on the corner of Donegal Pass were wine importers. (By permission of Ulster Folk and Transport Museum, WAG 1999)

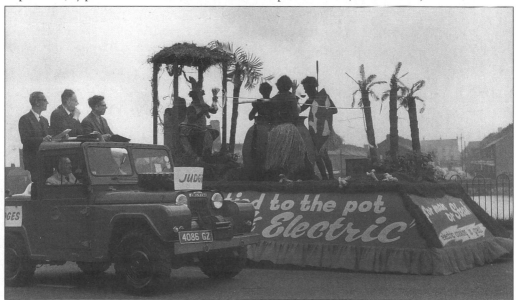

The Electricity Department's float in the Lord Mayor's Show, c. 1968. Astronomer Patrick Moore (centre, in the Land Rover) is one of the judges.

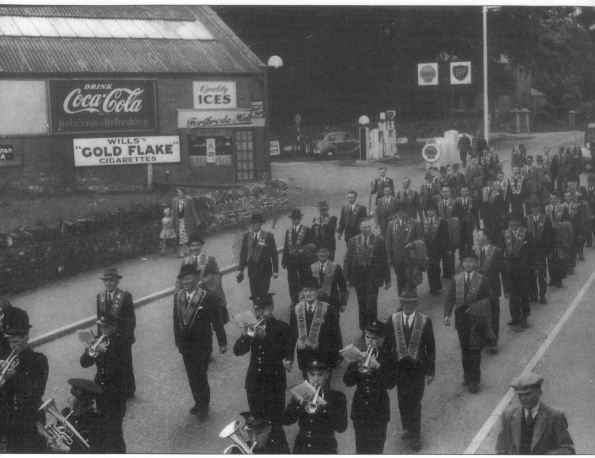

Deramore Purple Star, LOL 819, on its way from Newtownbreda village to Ballynafeigh Orange Hall, 12 July 1946. The photograph also shows the Upper Knockbreda Road/Saintfield Road junction as it was before first Supermac, then Sainsbury's and the new road system changed the landscape.

St Jude's Defenders Temperance, LOL 818, pictured in South Parade, Ballynafeigh, sometime in the 1920s. A locally well known member of the Lodge was Edward Downing JP, who with his wife ran a hardware, newsagent and funeral undertaking business in Ballynafeigh; they are remembered by Downing Memorial Park, Annadale Avenue, home of Shaftesbury Bowling Club.

Ballynafeigh Orange Hall, opened in 1887 by Colonel Saunderson MP, was built largely as the result of the efforts of Robert Owen, a gasworks employee and father-figure of Orangism in the area. To begin with the Hall was home to Loyal Union Lodge 985, which held its first meeting there in October 1887; it became District headquarters when No. 10 district was formed in 1896. The District's first Twelfth demonstration took place in 1896 at Belvoir Park, an occasion marred by excessive drinking by certain bandsmen. The hall has served the area in many ways: Cooke Centenary Presbyterian congregation worshipped there while their church was being built; relief organizations met to provide comforts for the troops during the Second World War; and meals were served to pensioners during the Ulster Workers' Strike of 1974.

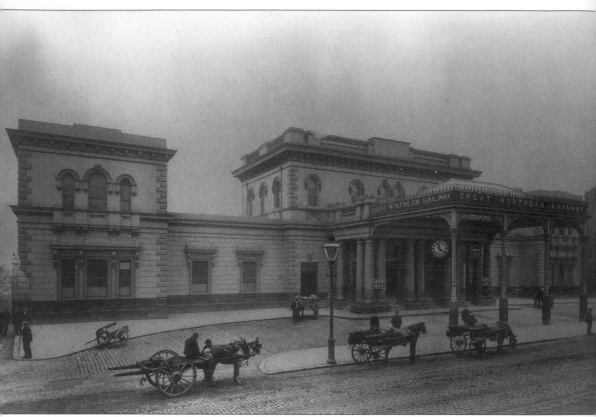

Great Northern Railway terminus, Great Victoria Street, *c*. 1895. The first railway line in Ulster opened in 1839 and connected the town with Lisburn. The Ulster Railway, as it was then known, built the Great Victoria Street station in 1848 to a design probably by its engineer John Godwin, who later founded the school of Civil Engineering at Queen's College. The columns seem unnecessarily Herculean for what they are given to carry. The porte cochère was added in 1891. The vehicles parked immediately in front are jaunting cars, to which the 'Cars in/Cars out' notices apply. (By permission of Ulster Museum W 10/29/19)

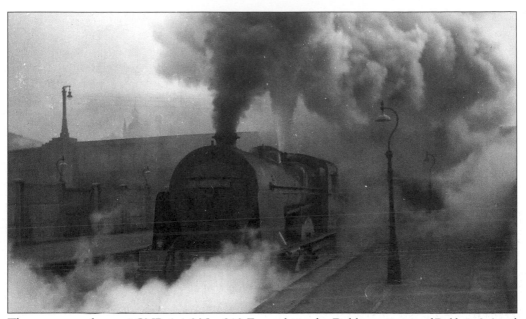

The romance of steam! GNR 4-4-0 No. 210 *Erne* taking the Dublin train out of Belfast, 3 April 1953.

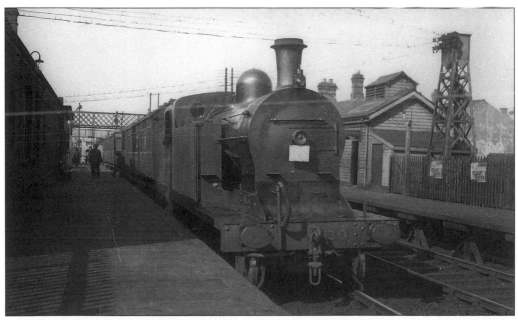

GNR(I) 4-4-2T No. 30 at Adelaide station (Lisburn Road), mid-1930s.

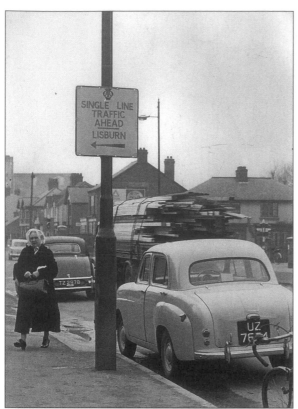

AA signing. From the early 1900s the Automobile Association had responsibility for erecting warning and directional signs and place names throughout Ireland. After The Second World War, during which many signs were removed in anticipation of invasion, responsibility for signposting was given to local authorities, the last AA directional signs being removed in 1957. The AA retains authority to erect special event signs. This view dates from the 1950s.

The big snow of 1963 brought traffic to a standstill in many places. This Post Office van, *en route* for Carryduff, ground to a halt near Commons Brae. Three drivers co-operated to rescue WLA67 and return it to Belfast – one occasion when the mail did not get through. From the left: William Stockdale, William Smith and Robert Wills.

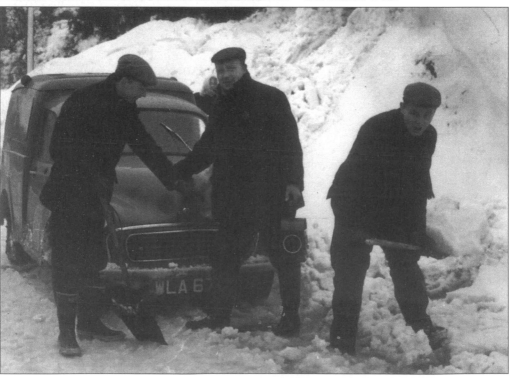

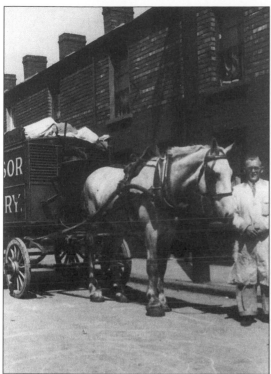

Above: Windsor Bakery delivery van in Eureka Street, off Donegall Road, 1939. The horse and cart had an advantage from the breadserver's point of view which the new electric vans lacked: the horse knew when to move on to the next house.

Above right: Geordie McAllister, a well known news vendor at Shaftesbury Square in the 1950s. The badge is a street trading licence.

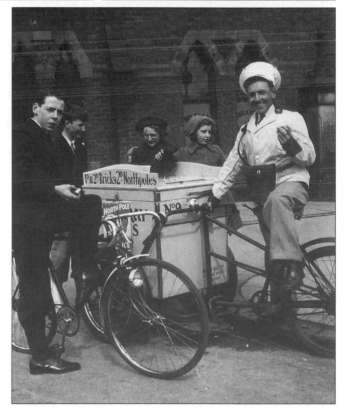

Right: Ice cream vendor Billy McAuley doing business outside the main gate of Botanic Gardens, 1939. The gatehouse of 1880, designed by William Batt Jnr, provides a backdrop.

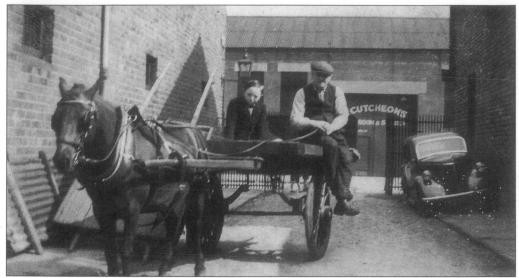

Harry O'Hagan with his son Patsy and Joey the pony in McAuley Court in the Markets (Cromac), 1953. To the left is Corry's (Cromac mineral waters) building, while on the right is an early Ford Popular. The Murdocks of Eliza Street were the family best known for the rearing of horses in the district. (J. O'Hagan)

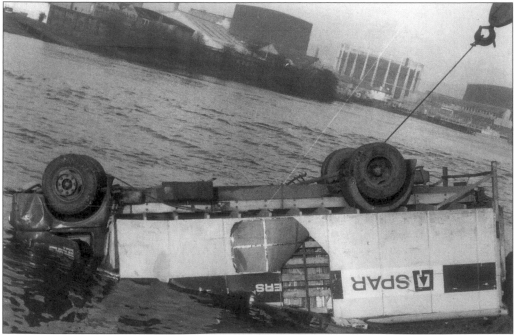

This accident happened in around 1970 on Annadale Embankment when the extremely frosty conditions caused the Spar vehicle loaded with canned goods to skid and plunge into the river. The driver was trapped in his cab, the door having suffered damage as the vehicle turned over. Fortunately a Co-op vehicle had been following and the quick-thinking driver was able to get a rope attached to the door and pull it open. The contents of the lorry were subsequently condemned but when officials arrived to remove them for dumping, they found the vehicle completely empty!

Three
Business

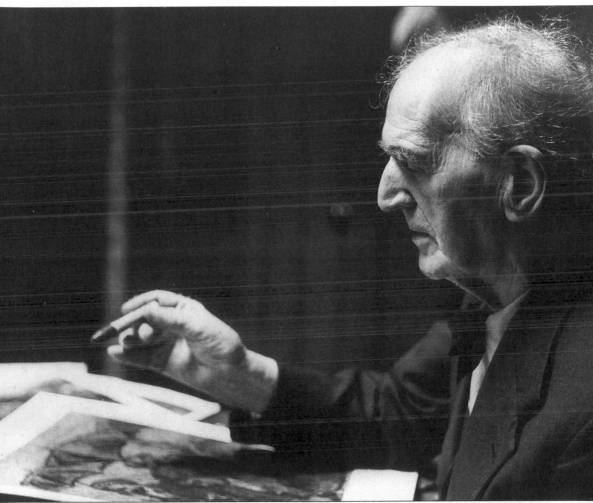

William Conor, 1881-1968. Born in Belfast and educated at the Government School of Design, Conor began his professional career as a poster designer, while painting in his spare time. He went on to study painting in Dublin and Paris; his first exhibition was in Belfast in 1914. During the First World War he was appointed an official war artist. He was elected to the Royal Hibernian Academy in 1947; in 1957 the Royal Ulster Academy elected him president. He was awarded an OBE in 1952. His pictures record the ordinary people of Belfast – the men, women and children of the Shankill and the Falls, slum dwellers many of them, Orange processions, shipyard workers. Critics noted his gift for depicting character and his sincerity. There is a joy in his pictures: the faces of his people are often lit up by smiles. (Photograph by Stanley Matchett FRPS)

Robert Wilson, founder of the Ormeau Bakery, learnt the trade from his elder brother John, who had a bakery in Great Edward Street, now Victoria Street. After the death of his brothers, John and Samuel, with whom he had been in partnership, Robert opened his first shop in Cromac Street in 1875. In 1890 he moved the business to its present site on the Ormeau Road, then on the outskirts of the city. The bakery prospered, with extensions built in 1896, 1906, 1927 and after the Second World War. Three generations of the Wilson family ran the business until it was taken over by Andrews Flour Mills in 1980.

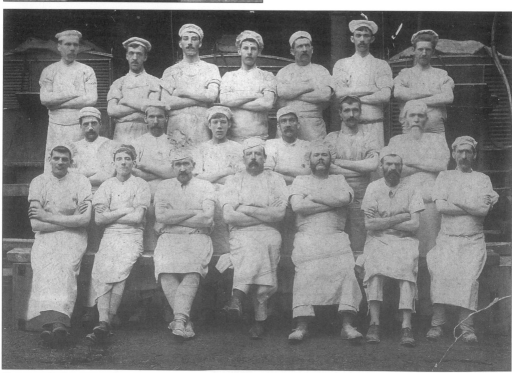

Ormeau Bakery employees in 1898. Behind the group are three of the company's horse-drawn delivery vans.

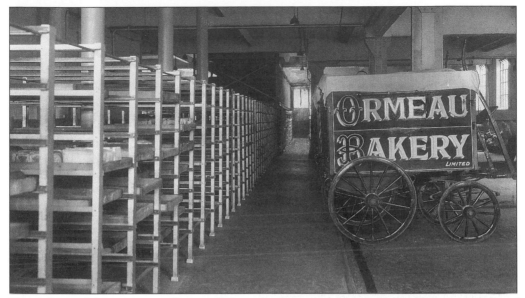

Horse-drawn delivery vans at Ormeau Bakery. In the very early days Robert Wilson, founder of the bakery, had the bread delivered by handcarts; when trade expanded he acquired four horse-drawn vehicles. In 1906, by then long established on the Ormeau Road, he had thirty-six horses stabled in a yard opposite the bakery.

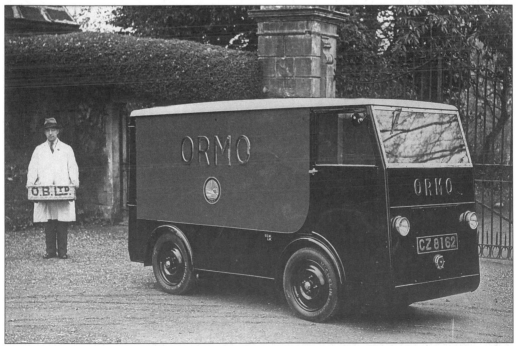

Ormeau Bakery prided itself on being ahead of its rivals in introducing new equipment and techniques. It was the first bakery to have a fleet of electric vans – fifty of them by 1935. The photograph shows breadserver William Hall beside one of them.

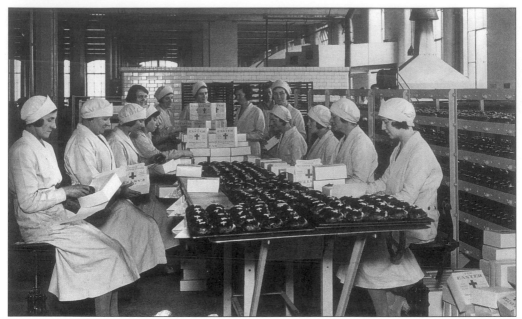

Packing hot cross buns at Ormeau Bakery in pre-war days. The girls' 'uniform' represents contemporary ideas of bakery hygiene.

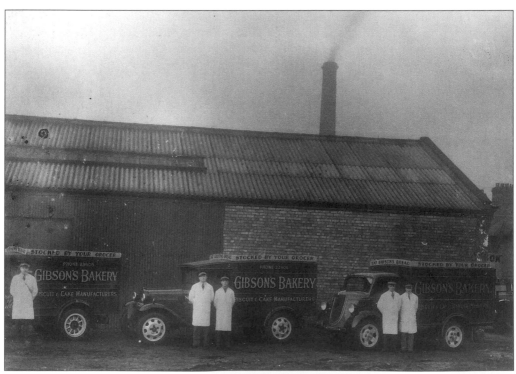

Gibson's Bakery delivery vans, mid-1930s. Alongside the bigger bakeries such as Ormeau and Belfast Co-operative, there traded a number of smaller businesses, of which Gibson's was one. Others included Inglis's, (Eliza Street), McWatters's (Cromac Street) and Hughes's (Springfield Road). (By permission of Ulster Museum, H10/33/27)

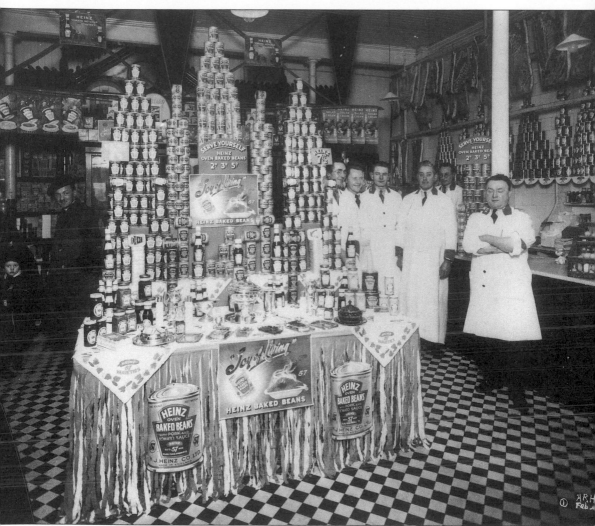

'Serve yourself' to Heinz baked beans at 2d, 3d or 5d per tin: a splendid display of Heinz products at the Ormeau Road Co-op in 1935. The Belfast Co-operative Society was founded in 1889; the Ormeau branch opened at 283 Ormeau Road in 1903 and the Lisburn Road shop in 1908. Ravenhill Avenue became an important centre of Co-op activity with the establishment of a bakery, formally opened on Easter Monday 1906, and a dairy, opened in 1913. (By permission of Ulster Museum, H10/62/17)

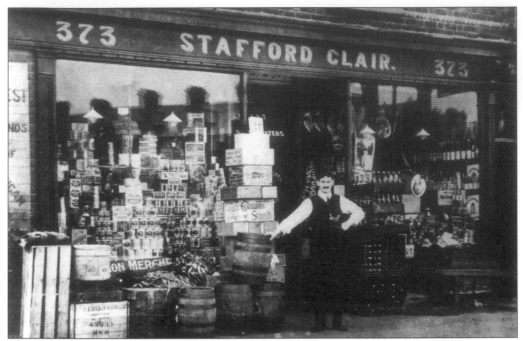

Manager Hugh Frew poses outside Stafford Clair's spirit grocery at the corner of Rushfield Avenue and Ormeau Road. Such establishments ceased to exist in Northern Ireland in 1923, though they continued for many years in the Irish Free State. Ballynafeigh Post Office, further right, was later moved to premises across the road.

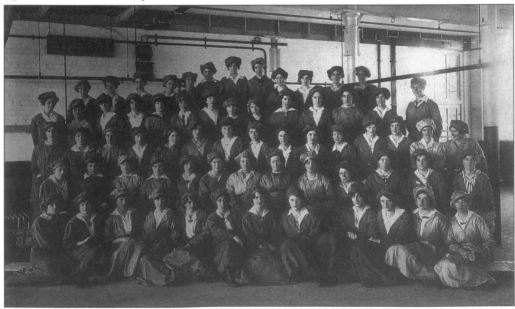

Laundry staff of the Lilliput Laundry and Dyeworks Ltd, Dunmurry, late 1920s. The laundry, established in 1873 by a Mrs McKinney, became the Lilliput in 1883. Cleaning and dyeing departments were added in 1898; hat remodelling and boot repairing joined them at a later date. Expansion of business took the company from its Cosgrove Street premises to a ten-acre site at Dunmurry in 1926.

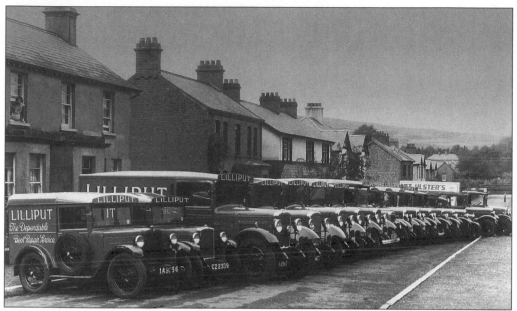

The Lilliput company's caption to this 1930s photograph proudly boasts that these vehicles were only a section of its transport fleet.

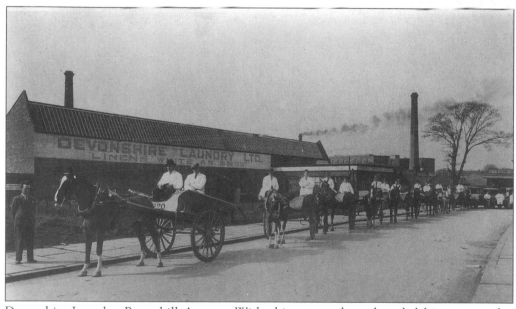

Devonshire Laundry, Ravenhill Avenue. With chimneys such as these belching out smoke, drying clothes at home must have been a problem in the days before washing machines and tumble driers. As the slogan proclaims the Devonshire undertook to solve it for you. The white coats of the staff back up the claim. (By permission of Ulster Museum, H10/58/4)

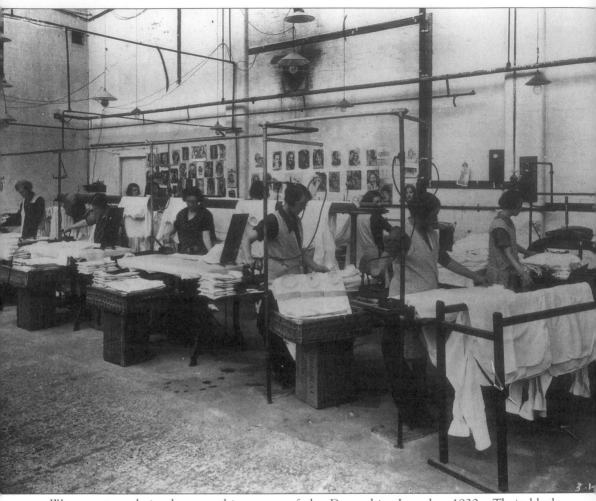

Women at work in the smoothing room of the Devonshire Laundry, 1930s. Their bleak surroundings are brightened by pictures of the film stars of the day. (By permission of Ulster Museum, H10/58/7)

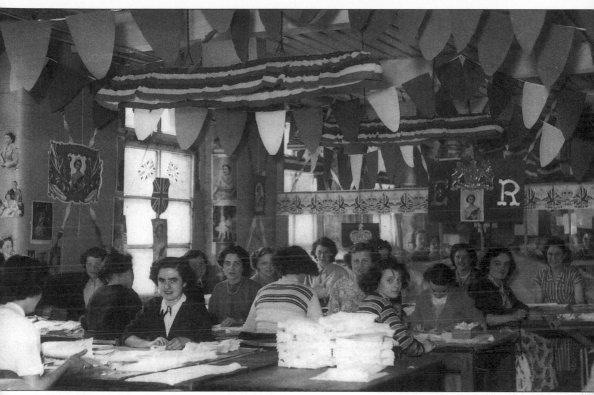

Wareroom at Gribbon Bros, handkerchief makers, in Adelaide Street, decorated for the coronation of Queen Elizabeth II, 1953. From right: Betty Langford, Violet Douglas, Freda Lilley; also included are Betty Forbes, Ivy Corry, Jeanie Kennedy.

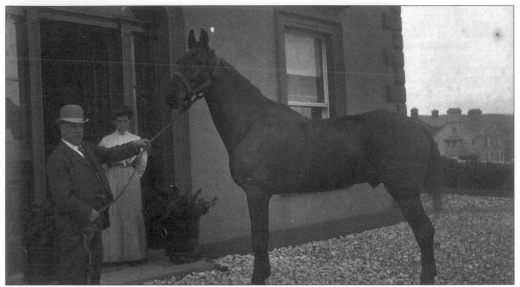

Robert Johnson, chairman of Thomas Johnson and Sons, who lived on the Malone Road, was elected councillor for Windsor ward on Belfast City Council in 1897 and advanced to alderman in 1916. The company, founded by Robert's father, was part of a coaching service to Dublin, carrying passengers to Banbridge (horses were changed at Hillsborough), from where another company took them on the next stage of their journey. The completion of the Belfast-Dublin railway line in 1853 forced the Johnsons to develop the business in other directions: coach hire, furniture removal and funeral furnishing. At one time the Company had sixty horses: Belgians for looks, Irish for strength. Four telephone lines (number 441) reflected the volume of business.

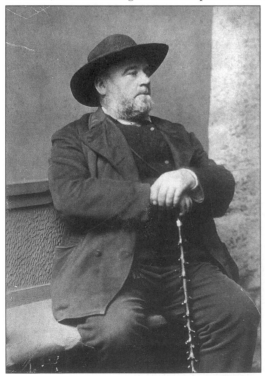

Henry Martin of Great Victoria Street set up a building business in around 1839. An early major contract was Elmwood church. The partnership of H. and J. Martin was formed when Henry was joined by his eldest son John; the company moved to its present premises, the Ulster Building Works, at 163 Ormeau Road in 1879. Building projects in South Belfast carried out by H. and J. Martin are: City Hall, the Opera House, hospital units at Purdysburn, Forster Green's and Musgrave Park, the agricultural building and halls of residence at Queen's University, Museum and Art Gallery, Stranmillis College, Fane Street School, Supermac, the bowling stadium at Shaw's Bridge and offices at Shaftesbury Square. Henry Martin died in 1898.

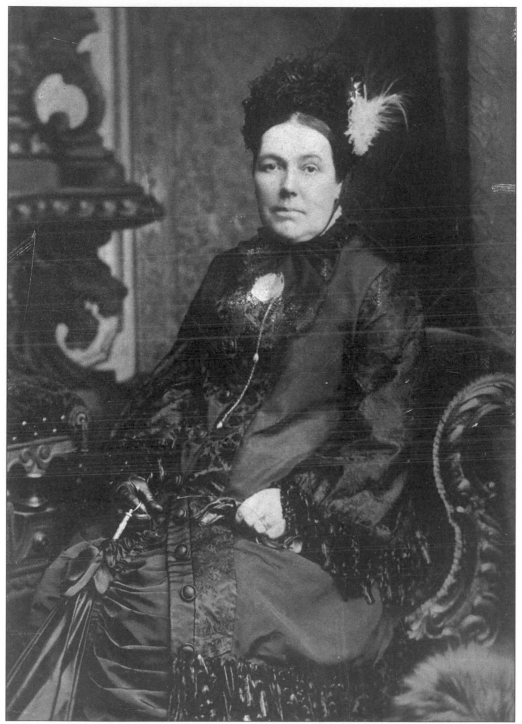

Margaret Fair, 1809-1885, wife of Thomas Johnson, posting master and contractor, of Wellington Street and later of Bedford Street. She was the mother of Robert Johnson. The business families of Belfast intermarried, creating a complicated network of relationships: for example, the Johnsons were related to the Martins (H. and J. Martin).

Another example of the intermarrying of commercial dynasties is provided by the wedding of Thomas Andrews, son of the Rt Hon. J. Andrews of Comber (linen, ropeworks), and Miss Helen Barbour, daughter of John D. Barbour of Conway, Dunmurry (linen), which took place on 24 June 1908 at Lambeg parish church. Thomas was managing director of Harland and Wolff, nephew of William Pirrie and designer of the *Titanic*. The couple set up home at Dunallen, 12 Windsor Avenue, Belfast. Thomas lost his life in the *Titanic* disaster, leaving a widow and a daughter, Elizabeth. Did the floral arrangements on the poles have special significance? (By permission of Ulster Museum, W 47/02/6)

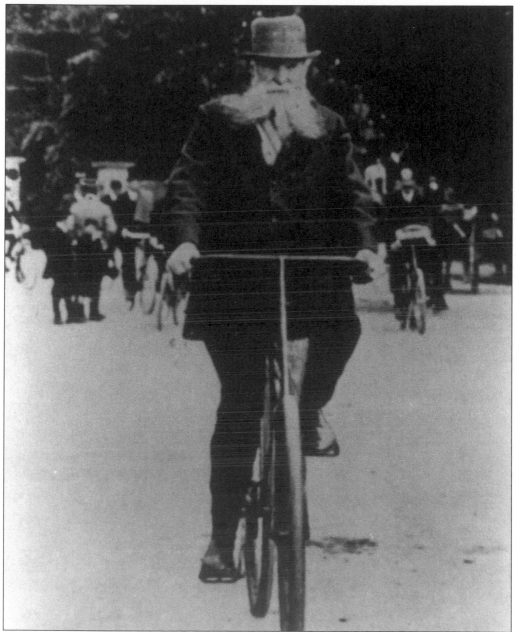

John Boyd Dunlop cycling in the Botanic Gardens. Born in Ayrshire, Scotland, in 1840, Dunlop qualified as a veterinary surgeon and moved to Belfast in his late twenties where he set up in business in Joy Street. He did not invent the pneumatic tyre but rather re-invented it: he developed the first practical form in 1888 to enable his invalid son to cycle in comfort over Belfast cobbles, according to one story, or to ease the transport of sick animals, according to another. His invention reduced the effort required and encouraged the development of cycling as a pastime. At the Queen's College sports in 1889 Billy Hume of the Cruisers Club won all the cycling races on a machine fitted with pneumatic tyres. Some thought this gave him an unfair advantage! The first tyres were made in Belfast, then in Dublin. Dunlop died in 1921. (By kind permission of Dunlop Tyres)

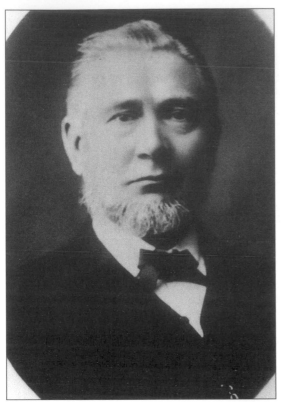

William S. Baird (left),1824-1886, and his brother George C. Baird (below), 1833-1875, bought the Ulster Printing Company in Arthur Street in 1861. Together they founded the *Belfast Evening Telegraph* in 1870. The brothers had had an ambition to publish a newspaper that would provide accurate, up-to-date reporting of events from a Conservative viewpoint for some time and had even gone so far as to announce the fact, but it took an advertisement for a new evening paper to galvanize them into action. The first number appeared on 1 September 1870, six days ahead of its rival. It cost a halfpenny and consisted of four pages; it sold 3,000 copies. The paper quickly became a success and new presses and eventually a move to new purpose-built premises in Royal Avenue were necessary to meet demand. (By kind permission of the *Belfast Telegraph*)

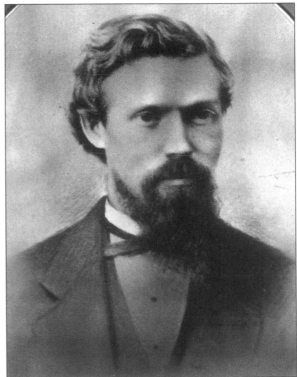

Robert Corry, 1800-1869, who founded the firm of J.P. Corry and Co. in around 1838; they were quarry owners, timber merchants, building contractors and ship-owners. Corry's company played a large part in the development of Belfast, building houses in what is now the university area, including Upper, formerly Corry's, Crescent (1846), where he lived at No. 10, and Lower Crescent (1852), harbour works and Assembly's College. The infamous 'Night of the Big Wind' of 1839, while causing hardship to many, gave Robert Corry a great business opportunity. A staunch Presbyterian, Corry served on the building committee of Elmwood church and he and his family met most of the cost. The spire, designed by his son John, was erected and paid for by the family in his memory in 1873.

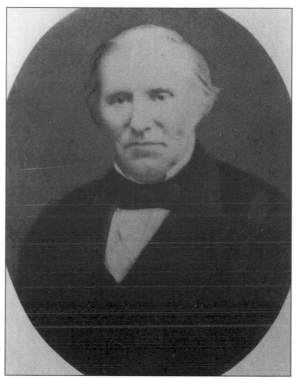

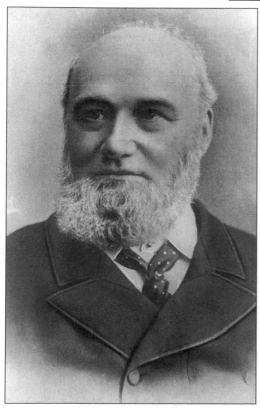

Sir James Porter Corry, 1826-1891, succeeded his father Robert Corry as head of the family firm. He extended its shipping interests, becoming Edward Harland's first Belfast customer. The *Jane Porter*, launched in 1860, was an iron ship; eleven more iron ships followed, all built in Belfast and named *Star of* In return Harland bought his timber from Corry. As well as following his business interests, James P. Corry found time for a host of good causes: the Society for the Prevention of Cruelty to Animals, the Irish Temperance League, the Belfast Clerks' Provident Association, YMCA and hospital and school boards. He was a member of the Belfast Harbour Board and represented Belfast and later Mid-Armagh in parliament where he was regularly consulted on shipping matters. He continued his family's support for Elmwood church where a plaque was erected in his memory by his employees who mourned 'the loss of a kind, considerate and generous employer'. He was made a baronet in 1885. His home, 'Dunraven', designed by his brother John, stood on the Malone Road where Cleaver Park now is.

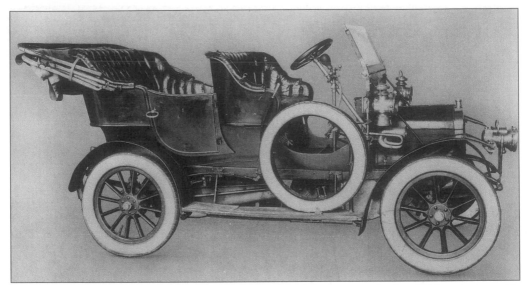

Chambers motor car, 1908. The vehicle was powered by a two-cylinder 6-7 hp engine with chain drive and patent gearbox in the back axle. There were three brothers involved in the company, John Henry, Robert Martin and Charles Edward; they produced their first car in 1904 at their Cuba Street works and set up a limited company in 1907. Expansion necessitated a move to larger premises at 126 University Street. The company produced a range of vehicles, including cars, vans, ambulances and funeral carriages. In spite of becoming agents for Renault cars and letting part of the works site to the Belfast Omnibus Company in 1928, the company went into voluntary liquidation in the 1930s, a victim of mass production methods.

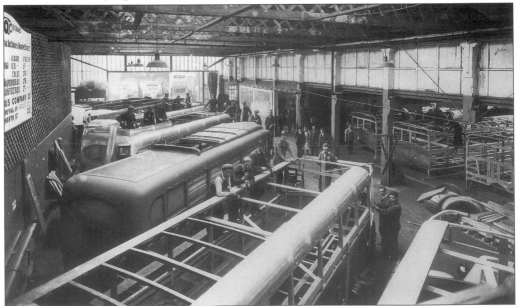

Belfast Omnibus Company's workshop at the former Chambers car factory, University Street, 1932. The works were used by the Northern Ireland Road Transport Board and the Ulster Transport Authority for bus maintenance and servicing until the Duncrue Street factory opened in 1949. A high proportion of the buses used by successive local transport bodies have always been made locally.

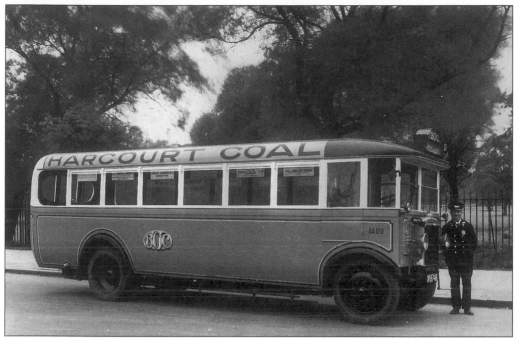

An Associated Daimler belonging to the Belfast Omnibus Company, 1927. Road transport developed very rapidly after the First World War. Northern Ireland led England in legislation to license companies and crews. From 1929 BOC bodies were built at the company's works in University Street.

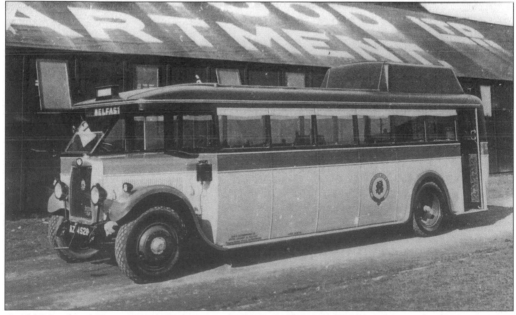

A 1930 Leyland Tiger TS2 belonging to H.M.S. Catherwood Ltd, seen outside the company's Donegall Road works. The luggage compartment on the roof was accessible from inside the vehicle. Catherwood's and BOC were the biggest operators before the Northern Ireland Road Transport Board was set up in 1935.

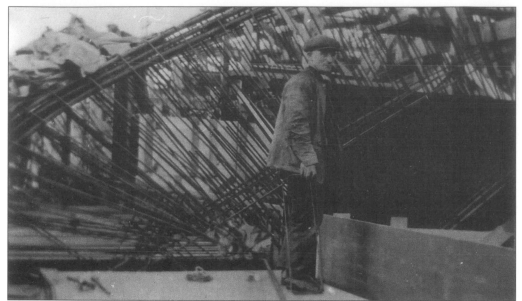

Constructing the roof of the King's Hall, headquarters of the Royal Ulster Agricultural Society, in 1933-34. Although the design came from an English architect (the Royal Society of Ulster Architects protested), the work was seen by the Northern Ireland Government as a means of reducing unemployment locally and the contract was carried out by J. and R. Thompson of Roden Street.

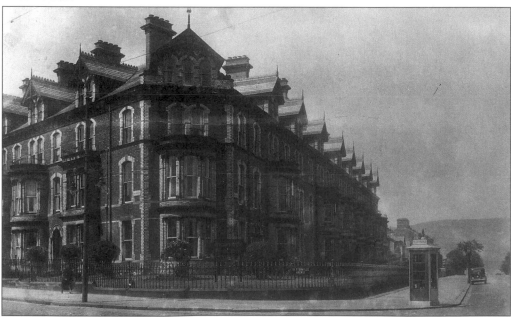

The Belgravia House, Lisburn Road, in the 1930s. It was built in 1878 and destroyed by the IRA on 27 July 1979. Once a hotel, the Belgravia in its final years had been a residential hostel for elderly folk run by the Northern Ireland Housing Association. There were thirty-six residents at the time of the bombing. With Department of the Environment help, the NIHA has built a new complex comprising twenty-four sheltered flats and forty-five apartments on the site. (By permission of Ulster Museum, H10/52/55)

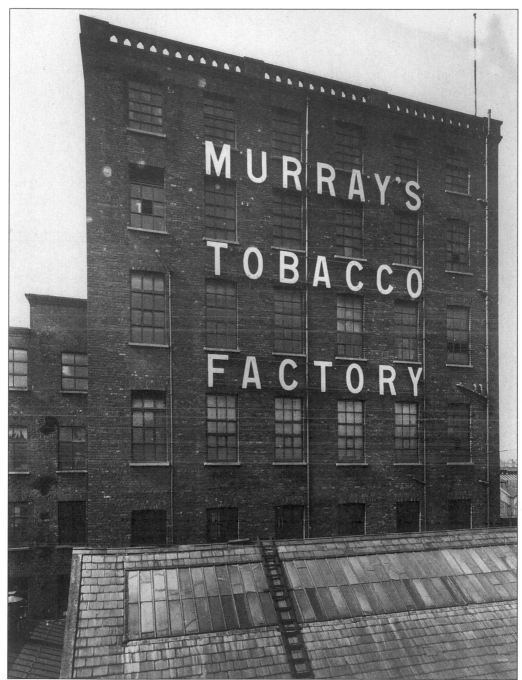

Murray's tobacco factory, Linfield Street, in 1935. The factory was named the Whitehall Tobacco Works in honour of Sir George White of Whitehall, Broughshane, Co. Antrim, the hero of Ladysmith during the South African War. Belfast's development as a port and ship-building centre led to the creation of businesses in imports such as timber, tobacco and flour. Murray's supplied tobacco goods to an international market. The Great Northern Railway's Great Victoria Street terminus can just be seen on the right. (By permission of Ulster Museum, H10/29/245)

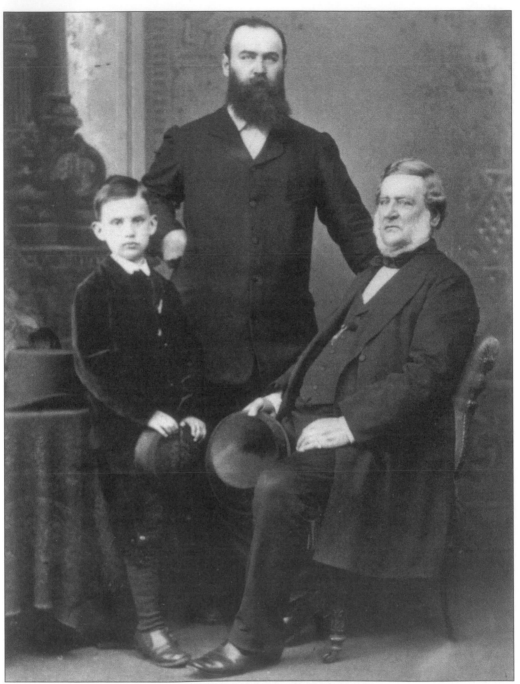

Three generations of the Stelfox family. James Stelfox (1809-1889), seated right, came to Belfast from Salford in 1854 to be manager of the Belfast Light and Coke Company, which subsequently became the Belfast Corporation Gas Department. His son, also James (1842-1910), centre, succeeded him in the gasworks and during his time the Middle Section Meter House and the office block were built. The boy is James Caldwell Stelfox (1871-1950), who made a career for himself in England. The best known Belfast Stelfox today is Dawson Stelfox who climbed Everest in 1993.

Left: The clock tower at the southern end of the long office block of Belfast Gas Works, Ormeau Road, designed in 1887-88 by architect Robert Watt. The original slated roof has been replaced by a copper cupola, the stone balustrade by iron railings. Belfast Gas Works, one of the first in Britain, began operations in 1823 and oil lamps gave way to gas in the streets of Belfast. The Gas Works was taken over by the town council in 1874.

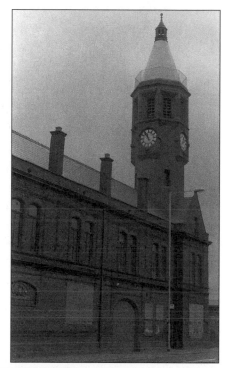

Centre: Belfast's coat of arms carved in sandstone in the pediment of the Retort House, Belfast Gas Works, built 1890-91. The gable is notable for its decorative brick panelling and terracotta frieze. The Retort House was popularly known as the 'Klondyke'.

Below: Unglazed terracotta panels of Renaissance putti holding garlands, and incorporating the Belfast coat of arms, punctuate the front of the long office building at Belfast Gas Works.

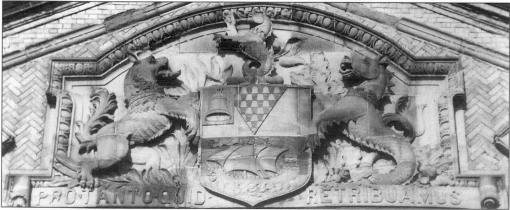

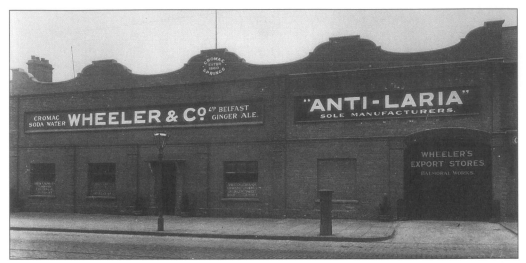

Good supplies of excellent water lay deep under the city in beds of Triassic sandstone, but except at a few places like Fountainville and Cromac it was not much used for domestic purposes until the nineteenth century. Wells were sunk to tap these supplies and a minor industry developed in 'aerated waters', claimed as a Belfast invention. Grattan's, Corry's, Ross's and Wheeler's became household names. Ross's had a well 420 ft deep in Victoria Square. The water was found to be equally good for distilling. One company, Cantrell and Cochrane, came to dominate the aerated waters trade, absorbing companies such as Ross's and Corry's. In 1900 it claimed to own the largest illuminated sign in the world, in Times Square, New York. (By permission of Ulster Museum, H 10/52/21)

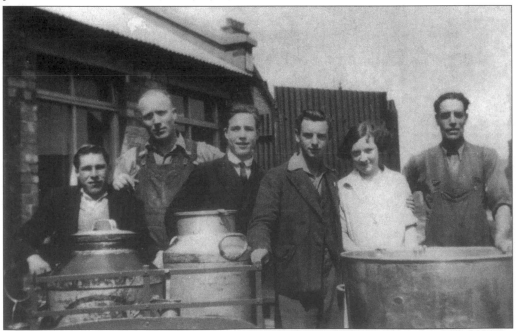

Mr Herbert Smith supervising the distribution of milk at Cregagh Dairies in Ogilvie Street, 1930. The man on the left owned the hand-drawn milk float from which he sold buttermilk from door to door. Cregagh Dairies was subsequently amalgamated with Kennedy Bros and relocated at Tate's Avenue.

Four
Health and Welfare

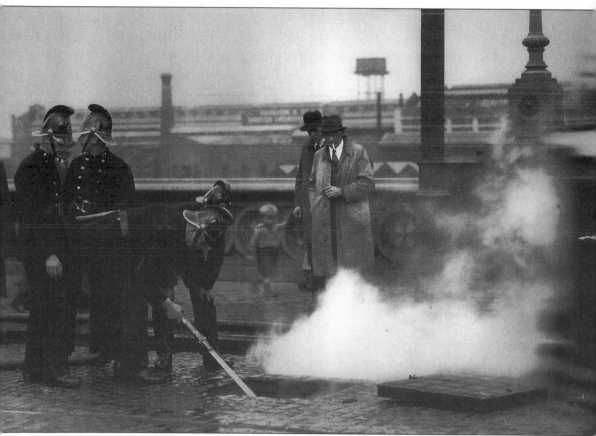

Hosing down a fire in the electricity supply system at the Albert Bridge, early 1930s. What price health and safety? And should the onlooker have lit up with all those fumes about?

Belfast Union Workhouse, Lisburn Road. The Irish Poor Relief Act of 1838 set up workhouses to be managed by Boards of Guardians. The Belfast Board met for the first time in 1839, acquired a twelve-acre site between the Lisburn Road and the Blackstaff Loaning (now Donegall Road) and opened the workhouse in 1841 with room for 1,000 inmates. It was built to the larger of the plans devised by George Wilkinson (architect to the Irish Poor Law Commission). The building would more than treble in size over the years. The photograph shows the Administration Block, completed in 1840. (PRONI HOS 4/1/10/14)

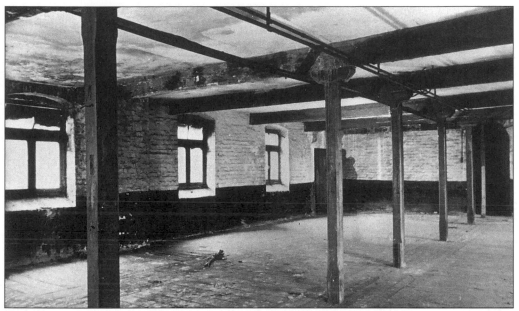

A ward in the workhouse. The buildings were intended to be plain and functional: inside, the unplastered walls were white-washed; rafters were left exposed because there were no ceilings. Wilkinson added two money-savers of his own: mortar floors rather than boards or flags, and sleeping platforms, on which straw mattresses were laid, on either side of an aisle, instead of separate beds. (PRONI HOS 4/1/10/10C)

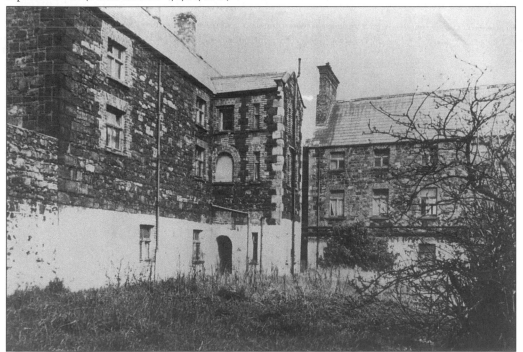

The women's yard with the cripples' ward on the right and the separation block on the left. Inmates were segregated by age, sex and physical condition. The breaking up of families greatly added to the pain of entering the workhouse. (PRONI HOS 4/1/10/13)

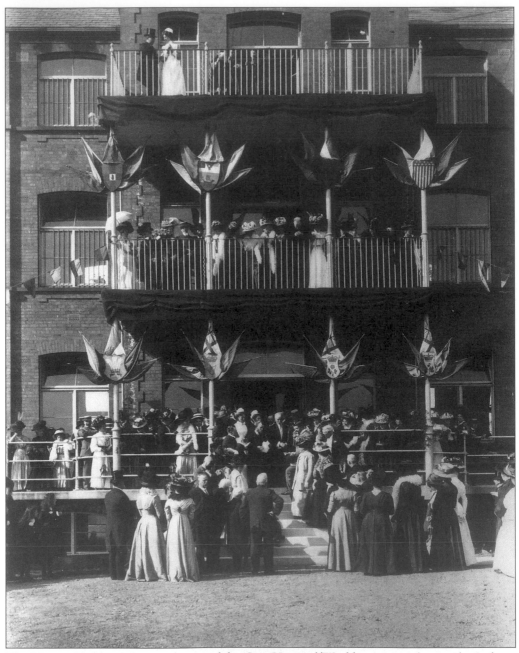

The Union Children's Hospital, part of the City Hospital/Workhouse complex on the Lisburn Road, was opened in 1908 and named the Dufferin Hospital; it cost £9,000. An extension costing £27,000 was added in 1932 and the combined buildings were named the Dufferin and Ava Hospital. At the same time as this extension was being built, a new Hospital for Sick Children was rising on the Falls Road. (By permission of Ulster Museum, H 10/52/14)

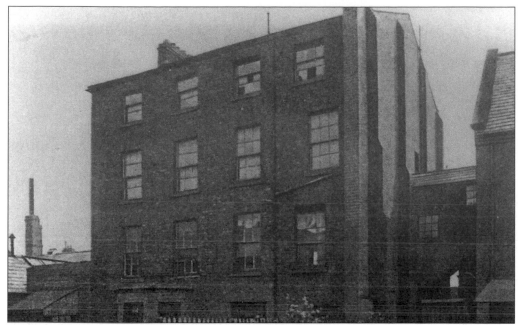

Ulster Magdalene Asylum for 'fallen women', Donegall Pass. By the end of the nineteenth century much of the charitable work done in Belfast was organized on a denominational basis. The Donegall Pass institution belonged to the Church of Ireland; the Presbyterian Church had a similar one in Sunnyside Street and the Roman Catholic Church at the Good Shepherd Convent on Ormeau Road. One thing they had in common was a laundry where the women earned their keep.

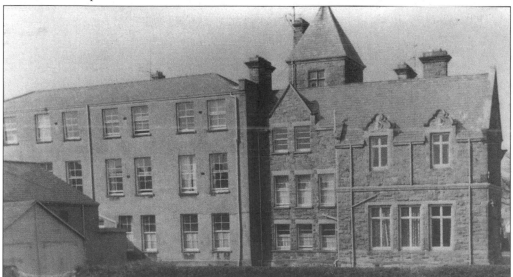

Haypark Residential Home, Whitehall Parade. In the 1890s it was the home successively of Felix McCarthy RM and S. Gregg, iron merchant. In around 1902 the building, then known as Whitehall, became the premises of the Edgar Home Laundry, a Presbyterian charity for 'fallen women', which it remained until 1932. From 1934 it housed Haypark Special School; during the Second World War, Templemore Avenue Hospital took it over when that hospital was bombed; this was followed by use as a geriatric unit. It is now a residential home for the elderly.

The Revd Francis Maginn (1861-1918), the son of a Church of Ireland clergyman in County Cork, lost his hearing at the age of five when he fell victim to scarlet fever. He was educated at the Margate School for the Deaf and at Gallaudet College, Washington. The death of his father cut short his studies and he returned to Ireland and became first superintendent of the Ulster Institute for the Deaf, then situated in Fisherwick Place. As a missionary to the deaf, Maginn travelled widely, visiting deaf people and finding employment for many of them in trades in Belfast. Gallaudet College conferred an honorary BD degree on him in recognition of his work. In 1911 he was recorded as living at 75 Lisburn Road.

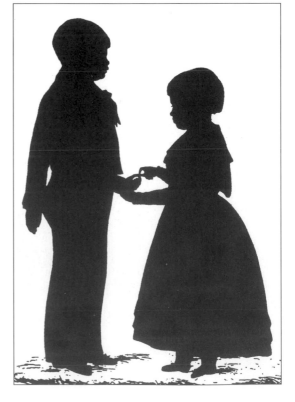

David Scott, a blind boy, and Sarah Armstrong, a dumb girl, conversing. Copies of the silhouette, drawn from life, were sold to raise money for the Ulster Institution.

The former centre of the Belfast branch of the Samaritans, Stranmillis Road. The organization was founded in London in 1953 by the Revd Chad Varah to give support to the despairing and the suicidal. It is non-denominational and non-political. The Belfast branch was established in 1961, with a Presbyterian minister, the Revd W.G.M. Thomson as director. Volunteers staff the telephones twenty-four hours a day, seven days a week. Belfast Samaritans opened in King Street, moved to Lisburn Road in 1964, Stranmillis Road in 1976 and, since 1989, have been located in Wellesley Avenue where in excess of 20,000 calls are received annually. (Photograph by Allan J. McCullough)

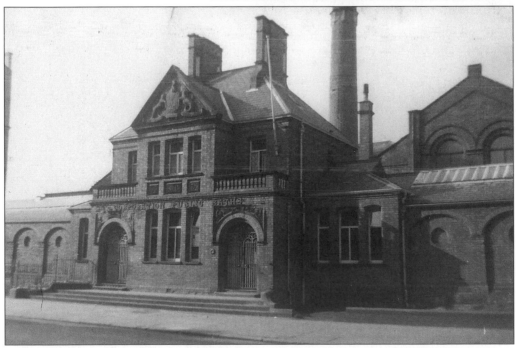

Ormeau Public Baths, 1887-89, by Robert Watt. Ormeau Avenue was part of a Corporation scheme to improve the city, as had been the development of Royal Avenue. The building of public baths here and elsewhere may be seen as a contribution towards improving the health of the citizens of Belfast. The building is now used as an art gallery. (Photograph by Janet Hearle)

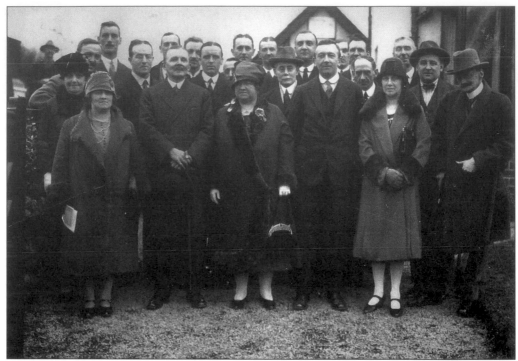

The official party at the opening ceremony at the first all-Electric House, Balmoral Avenue, 1928. In the centre is the Lady Mayoress, Lady Turner.

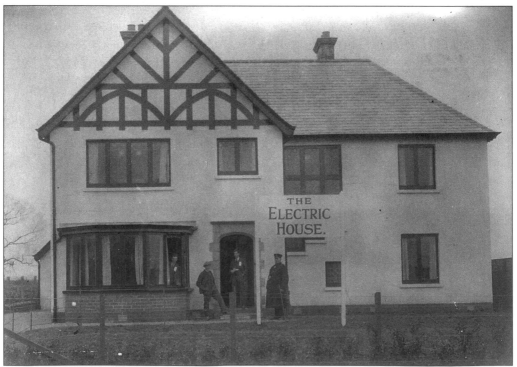

The Electric House, Balmoral Avenue, 1928.

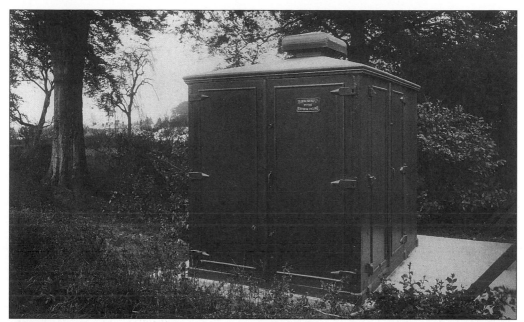

In 1923 the East Bridge generating station (built in 1898) was joined by the Harbour Power Station to meet the growing demand for electricity. This transformer at Maryville Park, Malone Road, is believed to be the first in the area (1927).

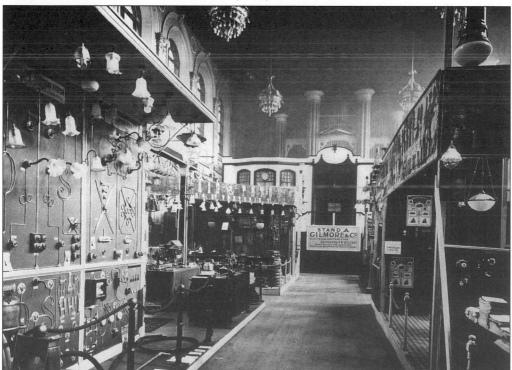

Belfast Corporation Electrical Exhibition of 'Appliances for Heating, Cooking, Lighting and Power' in Ulster Hall, 1911. Messrs Gilmore (Stand A) equipped a specially built show house with the latest in electrical fittings.

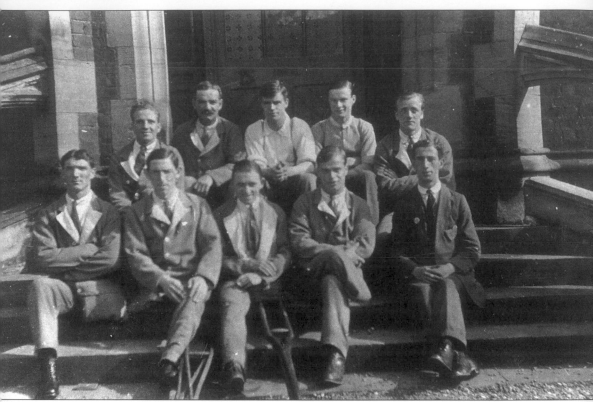

Amputees at the Military Hospital, Queen's University, during the First World War. British military fatalities for the First World War amounted to approximately 888,000 (200 per cent greater than for the Second World War); the wounded numbered in the order of four million. Many of these suffered injuries requiring amputation and the medical facility at Queen's handled its share. With hindsight it can possibly be argued that a fair proportion of amputations were expedient rather than absolutely necessary, but a surgeon could be sure of saving a greater proportion of lives by amputation in the same time that it would require him to attempt to repair a shattered limb. The pressures of battle and the volume of casualties had to be important factors in his decision making. (Martyn Boyd)

Five
Youth and Education

Linfield Public Elementary School, built in 1929, was one of twenty-six schools designed between the wars by R.S. Wilshere, architect to the Belfast Education Committee, which transformed school architecture in the city. He built schools which were bright, airy, spacious, cheerful places, the antithesis of nineteenth-century educational barracks. Instead of classes sharing a large hall there were rooms for single classes; rooms were provided for special subjects like woodwork; and there was an assembly hall. They were the first modern schools in Ireland. (By permission of Ulster Museum, H 10/29/255)

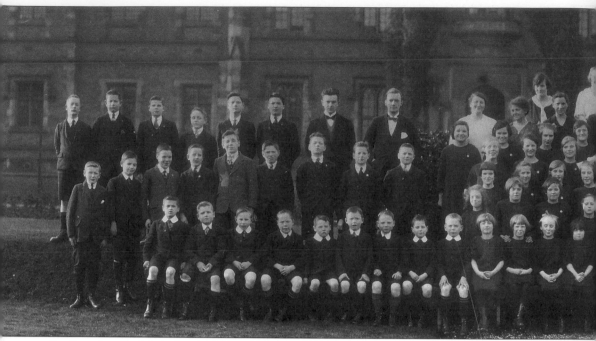

Pupils and staff of the school of the Ulster Society for Promoting the Education of the Deaf and Dumb and the Blind, Lisburn Road, February 1928. The principal was James Lilley, the matron Miss M. Clelland and the secretary Miss Shepperd. The school, opened in 1845, was the culmination of a number of projects to provide education and industrial training for the deaf, dumb and blind in Belfast. Discipline was strict, the diet uninteresting but plentiful and the importance of cleanliness emphasized. Religious instruction underpinned the whole regime. The children were given chores considered appropriate to their sex. It was intended that pupils

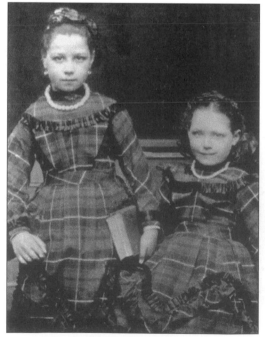

Lavinia and Emily Jones, c. 1872. They lived at 45 Ormeau Terrace. Their father, William, seems to have been something of an entrepreneur. He owned land in the lower Ormeau on which the gasworks and the surrounding estates were subsequently built; over the years he was involved in farming, real estate, fireclay manufacturing and brick making (at New Ballynafoy, now Ormeau, Road). He was manager of Newtownards gasworks, an importer and sand merchant.

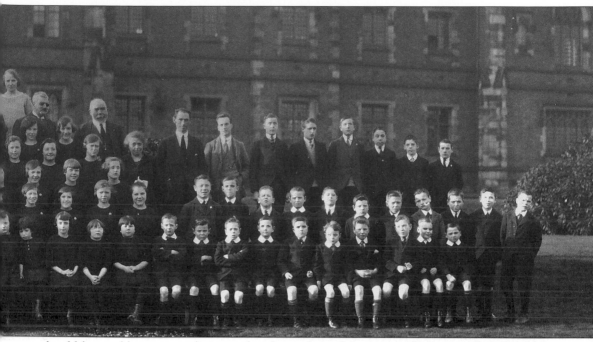

should leave able to earn a living and at first industrial training took place in the school but from 1853 apprenticeships were sought outside. The school depended on donations from supporters, so it often held public demonstrations of the teaching given. Designed by Charles Lanyon, the building, modelled on Elizabethan almshouses and meant to be built for £4,000, actually cost £11,000. More than 1,000 people were present when Lord Donegall laid the foundation stone in 1843. The central block contained a museum, offices and the principal's accommodation, and separated the male from the female sections. Dormitories on the second floor contained 150 beds. The building was demolished in 1963 and Queen's University Medical Biology Building occupies the site. The school is now established at Jordanstown.

Retirement of Dr Lamont (front row, fourth from left) as principal of Fane Street Public Elementary School, 1939.

St Jude's Public Elementary School, 'The Free Gift of William Fitzpatrick, 1884'. The opening of the school was long delayed; Fitzpatrick, a member of St Jude's church and its generous benefactor, first made his offer of a school in 1875. The first principal was John J. Dougan. The building also served as a parish hall for fifty years. The school closed in 1957 when a new primary school, Ulidia, opened nearby. One former pupil has painful memories of the foolishness of trying to persuade the principal that drawing, at which the pupil was good, should be as highly regarded in examinations as mathematical ability, which he lacked!

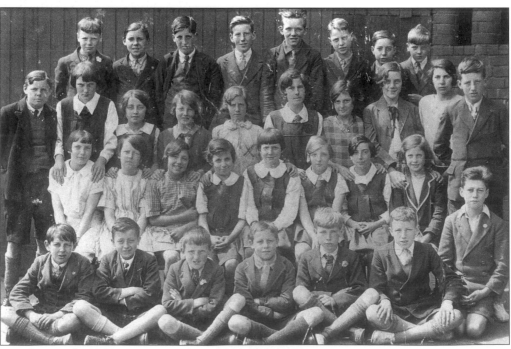

St Jude's pupils, 1930s. Most seem happy enough!

St Malachy's Girls' School (also known as the 'Young Ladies' School'), Sussex Place, in 1939. The cost of building the school and the adjacent convent in 1878 was met by Matthew Bowen, the proprietor of the Royal Hotel; the architect of the school was Timothy Hevey. The boys and girls, once educated separately, now share a new school building in Eliza Street. (By permission of Ulster Museum, H 10/29/314)

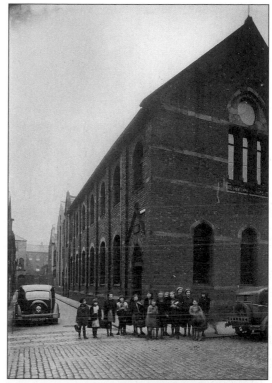

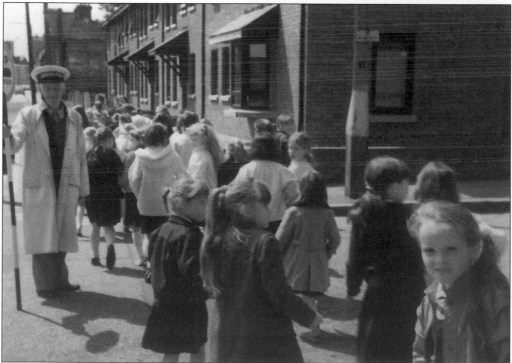

'Young Ladies' leaving St Malachy's for the last time, watched over by their lollipop man. The school closed in 1988.

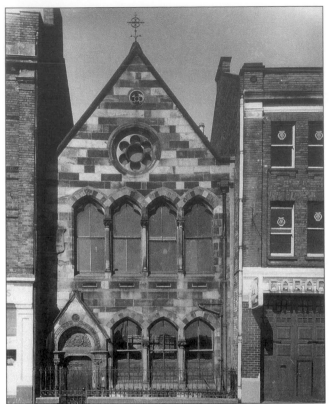

St Malachy's Christian Brothers' School, Oxford Street, near the Queen's Bridge, was opened on 1 October 1874 and from that date until 1929 catered for primary and secondary education. Thereafter it was a primary school. The cost of the school in 1874, including the site, was £2,000 which was met by a bequest from a Mrs M. Magill. The architect was Alex McAllister who also designed a number of Catholic churches and other buildings in Belfast. Its roll of past pupils numbers many names of clergy and laymen who have held distinguished positions in church and state. It closed in 1963. The building is now used for commercial purposes. (J. O'Hagan) (© Crown copyright. Reproduced with the permission of the Controller of Her Majesty's Stationery Office)

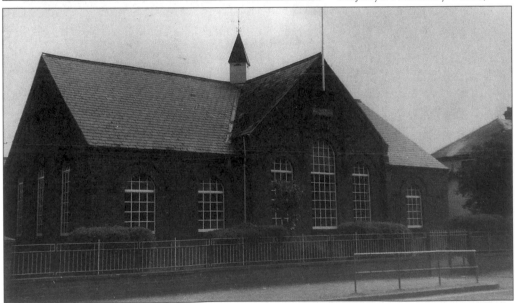

Malone Primary School, Balmoral Avenue. The original Malone School, this building's predecessor, was built by Malone Presbyterian church. Falling numbers forced the Belfast Education and Library Board to close the school in 1989; thereafter it served briefly as premises for Forge Integrated Primary School, an establishment associated with Lagan College. It has since been demolished; houses now occupy the site.

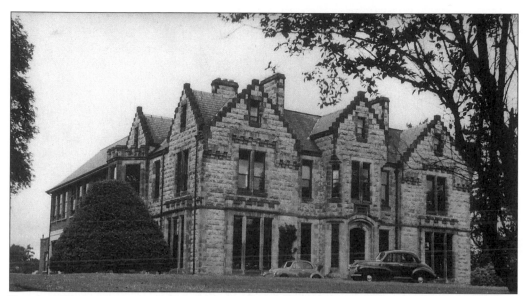

Royal Belfast Academical Institution, Inchmarlo. The preparatory school opened on 3 September 1917 at 106 Marlborough Park, Inchmarlo, with thirty-eight boys and three teachers. Numbers grew and eventually larger premises had to be found. 'Mount Randal' in Cranmore Park was purchased and the school moved there in September 1935. Further accommodation was built and the house was renamed Stirling House, after J.H. Stirling, chairman of the board of governors and a generous donor to the school. However, the old name, Inchmarlo, has remained in use.

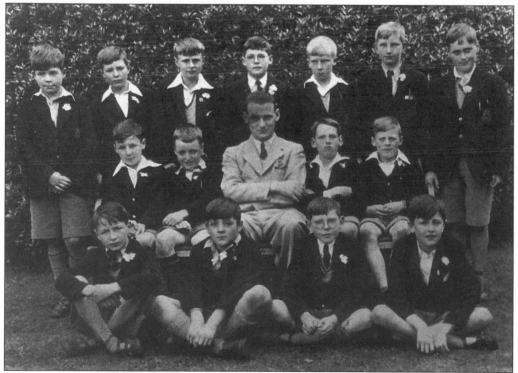

Mr Stewart and his class at Inchmarlo, 1935.

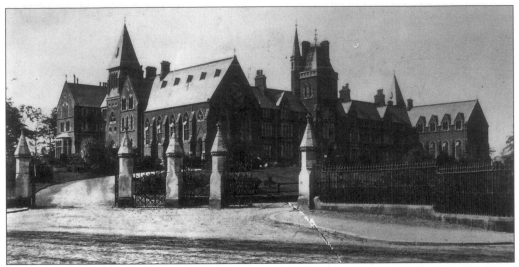

Methodist College, Malone Road, built 1865-68. The competition to design a Wesleyan Methodist College was won by William Fogerty of Limerick. The Gothic style of the building underlines the school's ecclesiastical connections; it contrasts effectively with Lanyon's Tudor Queen's College across the road. Bishop Knox had hoped to build a Church of Ireland cathedral on the site.

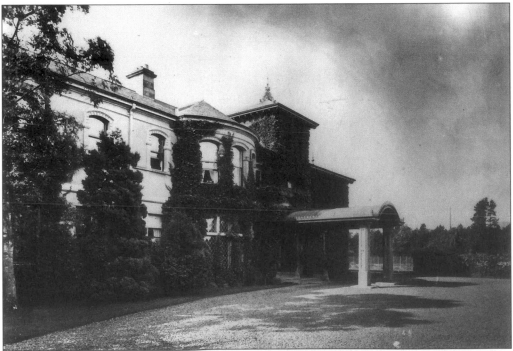

Strathearn House, Finaghy, built in the mid-nineteenth century by the Barbour family of linen merchants, was requisitioned for use by Harland and Wolff during the Second World War. In 1945 it was bought by Princess Gardens School as premises for a boarding department and junior school, and renamed Colinmore. Princess Gardens in University Street amalgamated with Colinmore on the site in 1967 and was united with Ashleigh House in 1987 as Hunterhouse College.

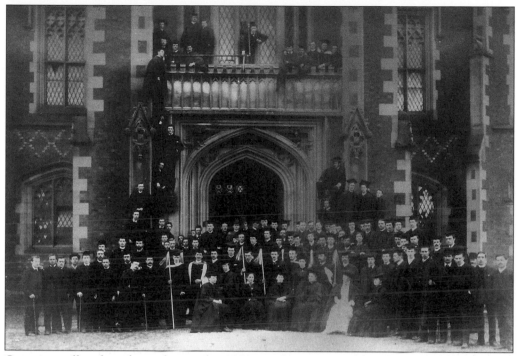

Queen`s staff and students during the 1880s, a date suggested by the presence of women students. Women were admitted for the first time in 1882-3, to arts classes. Florence Hamilton, who was to be the mother of the writer C.S. Lewis, was one of the first women undergraduates (front row, extreme left, seated).

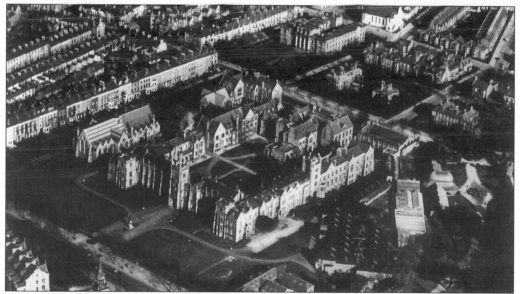

Aerial view of Queen's University, late 1930s. The Sir William Whitla Hall and the new Physics Building have yet to come – space would be found for them by demolishing old buildings. The Social Sciences Building, the Library Tower and the Administration Building further altered the appearance of the site in the 1960s. At one point a multi-storey car park on the front lawn was being projected; fortunately nothing came of it.

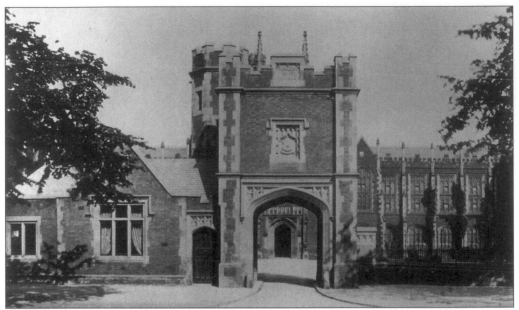

Hamilton Tower and Gate Lodge at Queen's. Built in 1907, the Tower commemorated the 'reign', from 1889 to 1923, of the third president of Queen's College and the first vice-chancellor, the Revd Thomas Hamilton. It was demolished in 1922, perhaps because it obscured the view of the new war memorial. Carved stones from the structure survive, built into garden walls at Lennoxvale.

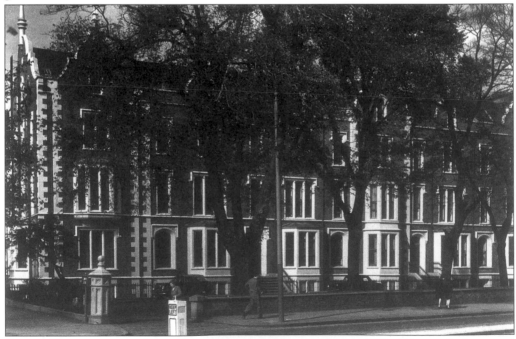

Queen's Elms, a terrace of seven Jacobethan-style houses built in 1859 by Thomas Jackson, and later served as student accommodation and housed the women students' hall. It was demolished in 1965. The elm trees in front of the terrace had to be cut down in the 1970s, victims of Dutch elm disease.

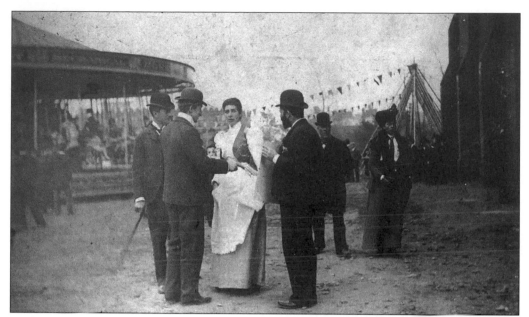

Students' union bazaar at Queen's College in 1894, one of the social events of the year. Its purpose was to raise funds for building a students' union. Members of the Northern Ireland aristocracy were persuaded to join in running stalls, a ploy which drew the Belfast public in large numbers. A Board of Works letter pointed out that the College should have first obtained its permission under the fire regulations to hold the bazaar.

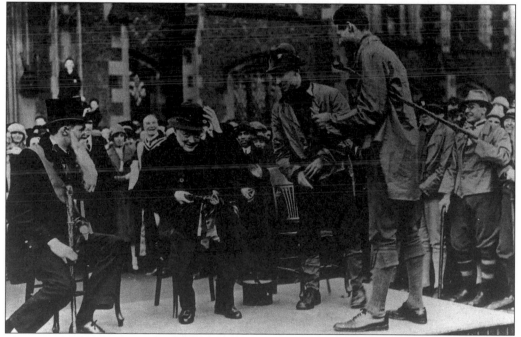

The ragging of Winston Churchill at Queen's University, 1926. The future Prime Minister appears to be donning an 'Oirish' hat under the supervision of two students in the guise of stage Irishmen. He is holding a shillelagh, no doubt also a gift from the students. The presence of figures in academic dress suggests that the occasion had a more formal side too.

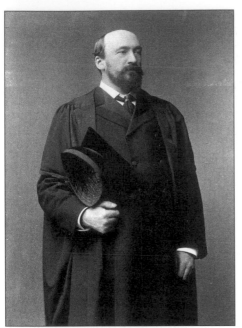

Sir William Whitla, 1851-1933. A Queen's College medical graduate (MD 1877), Whitla occupied the chair of Materia Medica at the College and University from 1890 to 1919. His published work included the *Dictionary of Medical Treatment*, which was widely translated, and *Elements of Pharmacy, Materia Medica and Therapeutics*. In 1909 he was elected president of the British Medical Association; he was later appointed physician to George V. Queen's stood high in his affections: he served as pro-vice-chancellor and represented the university in Parliament from 1918 to 1922; he helped to endow the Whitla Medical Institute, left his home in Lennoxvale to the University (now the vice-chancellor's lodge) and money to build the Whitla Hall. He was knighted in 1902.

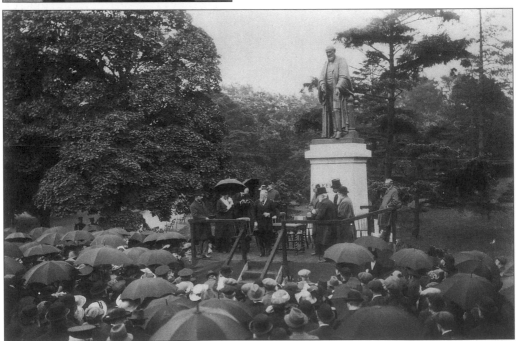

Unveiling the statue of Lord Kelvin in Botanic Gardens, June 1913. William Thomson was born in College Square East in 1824 and educated at Glasgow University and Cambridge. He held the chair of Natural Philosophy at Glasgow for fifty-three years. He formulated two great laws of thermodynamics, of equivalence and of transformation, and enunciated the doctrine of available energy. He laid a successful trans-Atlantic cable in 1866. He became a Fellow of the Royal Society in 1851 and received the OM in 1902. Thomson was ennobled as Baron Kelvin of Largs in 1904. He was buried in Westminster Abbey. (By permission of Ulster Museum, H 10/79/16)

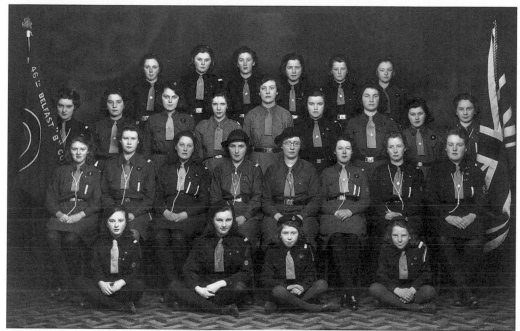

The 46th Company Girl Guides attached to Windsor Presbyterian church, c. 1943. The 1920s and 1930s saw a great expansion of the Girl Guide movement with many churches in South Belfast setting up companies. A cadet company for the training of adult leaders was established at Stranmillis College soon after it opened in 1924. The captain of the 46th, Miss Jo Nixon, is fourth from right, second row; on her right is Peggy Smyth who later became general secretary of the Ulster Girl Guides' Association.

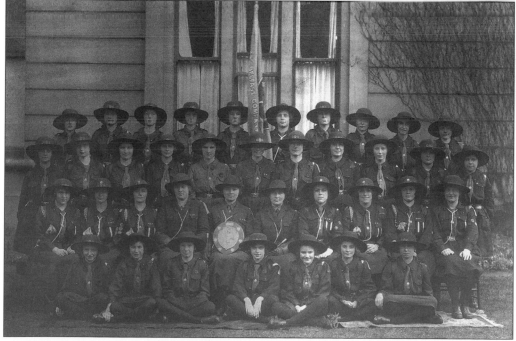

The 24th Company Girl Guides attached to Ashleigh House School, 1924.

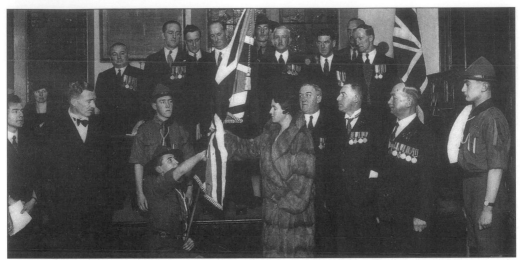

Mrs F.H. McClinton presenting the King's Colour to the 38th Belfast Troop of Boy Scouts (Crescent Presbyterian church) on behalf of the 10th Royal Irish Rifles Memorial Association, November 1934. Captain F.H. McClinton, president of the association, is on the left; Mr E.S. Moore MM, Honorary Secretary, and Mr T.H. Stafford MSM, chairman, are on the right. David Stewart, receiving the Colour, later became Professor of Paediatric Dentistry at the Royal Victoria Hospital, Belfast. Also included in the photograph are Sydney Hamilton, scoutmaster and principal of Mossley School (immediately in front of platform); Bob Mulholland, group scoutmaster, who ran a tool shop in Lower Ann Street (behind RIR members); and Leslie Stewart, later Secretary of G. Heyn and Sons Ltd (Head Line), on the right.

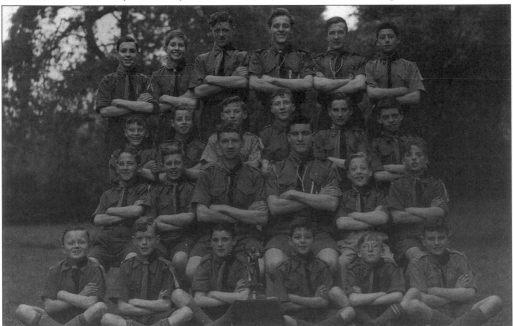

The 38th Belfast Boy Scouts (Crescent Presbyterian church), winners of the Cleaver Trophy for Scoutcraft, 1949. The group was founded by Bob Mulholland in 1925. George Barclay (second row, fourth from right) was leader for twenty-five years and also District Commissioner in South Belfast. In 1981 he was awarded the Silver Wolf, the highest award in scouting.

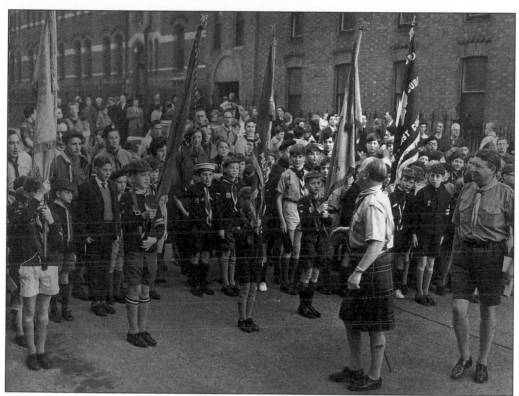

Opening of the South Belfast District Scout
Headquarters in the former Fountainville
School on Saturday 15 October 1966 by the
Chief Scout, Sir Charles MacLean. The
preliminaries had to take place in the
University Methodist church hall, with the
Chief Scout then crossing the road to cut the
ribbon, because building work had proceeded
more slowly than planned. To enter the
headquarters it was necessary to walk on planks!
George Barclay, District Commissioner for
South Belfast, is on the right.

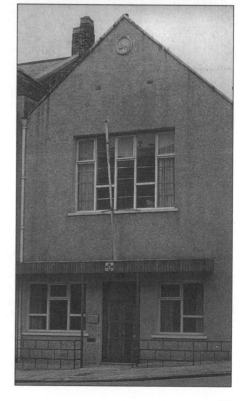

The former school attached to Fountainville
Presbyterian church, Fountainville Avenue, built
in 1884. The school closed in 1939, after which
time it served as commercial premises. It was
acquired by the Boy Scouts for their district
headquarters in 1965; it has recently passed out of
Scout ownership.

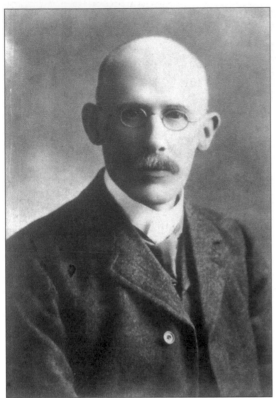

William McVicker worked among the children of the Donegall Pass area as secretary of the Charlotte Street Sunday School attached to St Mary Magdalene church. After reading a newspaper article about the recently formed Boys' Brigade organization he decided that the BB must be extended to Ireland. He went to Glasgow in 1888 to meet the organization's founder, William Smith. As a result of his efforts the 1st Belfast Company (also the first company in Ireland) was established at the end of 1888, with forty boys. McVicker remained company captain until his death in 1925, a period of thirty-six years.

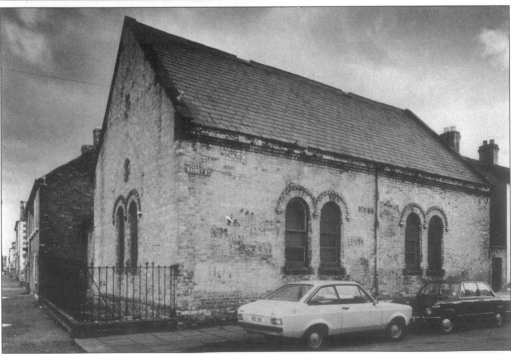

Charlotte Street hall, Donegall Pass, attached to St Mary Magdalene church, where William McVicker established the 1st Belfast Company of the Boys' Brigade in 1888.

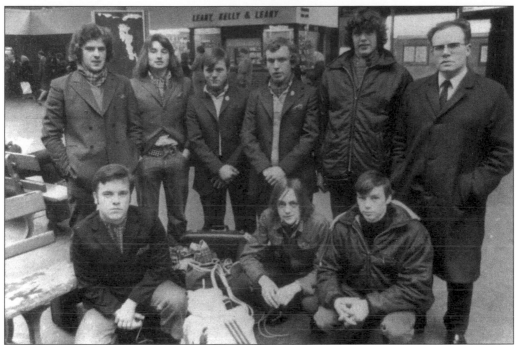

Members of the 80th Company BB (Donegall Pass Presbyterian church) who travelled to Scotland with their captain Maurice Williamson to take part in the United Kingdom finals of a BB five-a-side football competition in around 1969.

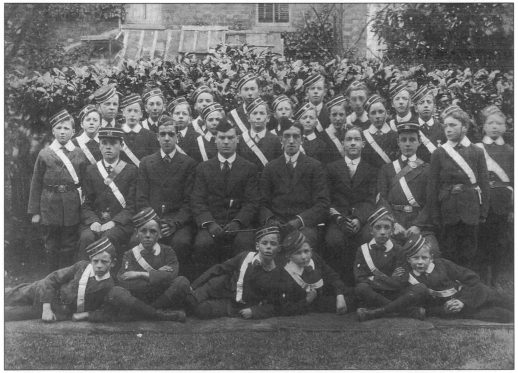

Members of the 26th Company BB (Fountainville Presbyterian church), 3 May 1913.

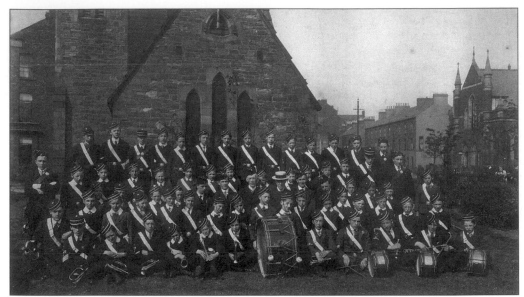

The 1st Belfast Company BB outside the former St Mary Magdalene church hall, Shaftesbury Square, 1914. The company held its first inspection in the Exhibition Hall, Botanic Gardens, on 31 May 1889. The Mayor of Belfast, Charles C. Connor, was chairman and the inspecting officer was Col. A.F. Kidston of the 42nd Royal Highlanders. The first company camp took place at Killough, County Down, in 1892. In 1933, boys from the First took part in the BB Jubilee Demonstration in the Royal Albert Hall, London.

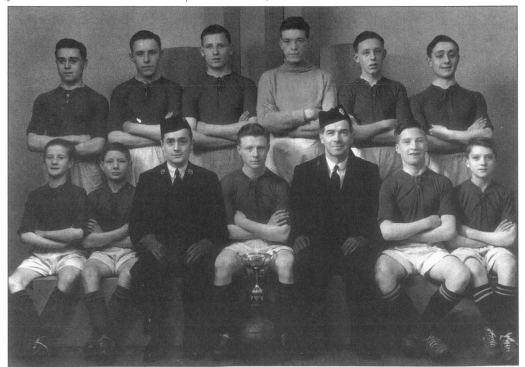

The 7th Belfast Company BB (Great Victoria Street Presbyterian church) football team with their trophy. The company captain is Mr William Henry.

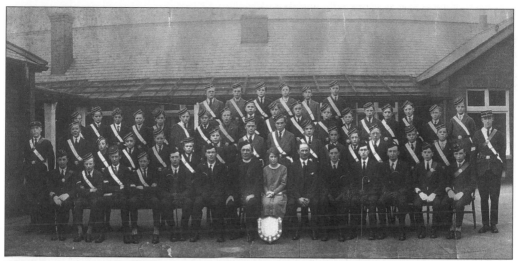

The 7th Company BB (Great Victoria Street Presbyterian church) at the Cripples' Institute, Utility Street, 1925. The connection between the Institute, now the Northern Ireland Institute for the Disabled, and the Boys' Brigade has always been strong, an early example of PHAB, perhaps. The clergyman is the Rev. T.A. Smyth after whom the Smyth Halls, Fountainville Avenue, were named.

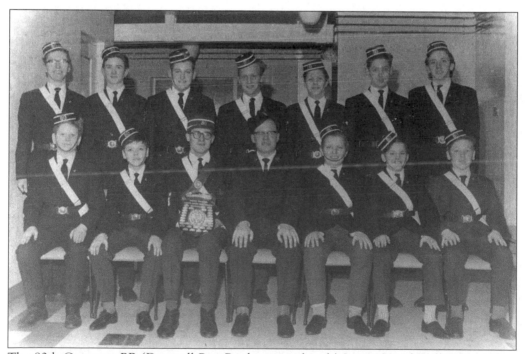

The 80th Company BB (Donegall Pass Presbyterian church) Junior Squad Drill Competition winners, c. 1964. Maurice Williamson, the captain, front centre, is now employed in an administrative capacity in Boys' Brigade House.

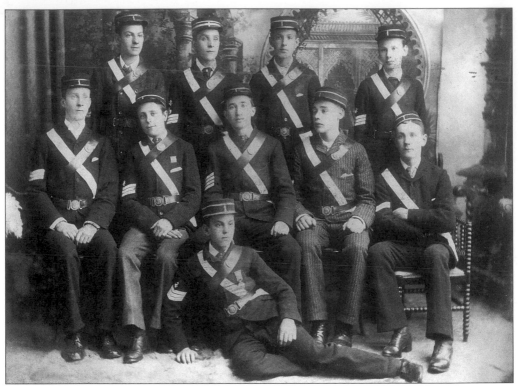

NCOs of the 1st Belfast Company BB, *c.* 1910. The size of the group suggests a large company of boys in the ranks, perhaps as many as sixty, as well as a strong commitment among the senior members.

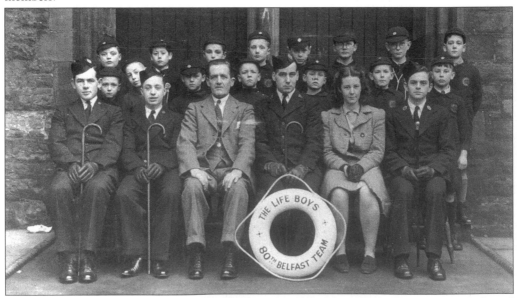

80th Company Life Boys (Donegall Pass Presbyterian church), *c.* 1946. These officers believed in leading from the front! From left: James Courtney, Robert Mahoon, Councillor William Lawther (company president), Cecil Arlow (leader-in-charge), Jean Hillick (pianist) and Jack McClelland.

Six
Religion

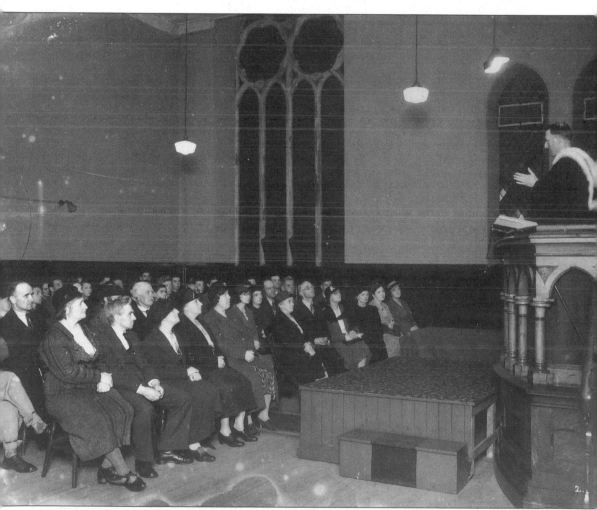

Service at the Kinghan Mission to the Deaf, now the Kinghan church, Botanic Avenue, 1939. The Mission was established in 1857 by the Revd John Kinghan, principal of the Deaf and Dumb and Blind Institution on the Lisburn Road. The first premises owned by the mission, The Bethel (1878), were at the Sandy Row/Donegall Road junction; the Botanic Avenue building was acquired from the Seceders in 1899. (By permission of Ulster Museum, H 10//29/67)

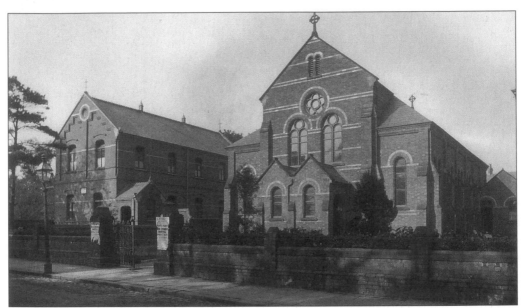

St Brigid's church, Derryvolgie Avenue. In penal times Catholics met to hear Mass celebrated at Friar's Bush on what is now Stranmillis Road. The name and order of the eponymous friar are lost in the mists of time: the stone claiming to mark his grave is not to be taken seriously. But the names of clergy from the eighteenth century are known. After premises were leased in Mill Street near Castle Street in 1769 Masses ceased at Friar's Bush. The sacrament was again celebrated in South Belfast during the famine of the 1840s when many Catholics sought refuge in the workhouse. Housing development in the Malone area meant the employment of servants, many of whom were Catholics and who wished to have a place of worship near at hand. Bishop McAllister was sympathetic and land was leased and a church in a vaguely Italian-Romanesque style was built (consecrated 1893). The congregation, having outgrown this building, has erected a new church nearby.

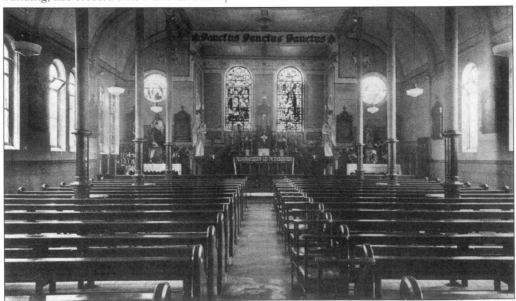

St Brigid's Catholic church, Derryvolgie Avenue: the interior of the 1893 building.

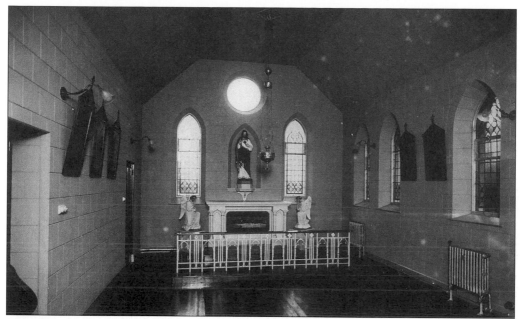

Chapel at the Good Shepherd convent (Ardmore Avenue) in the 1930s. It was used by Good Shepherd Sisters devoted to a life of prayer and contemplation. The chapel was demolished in 1995. (By permission of Ulster Museum, H 10//62/19)

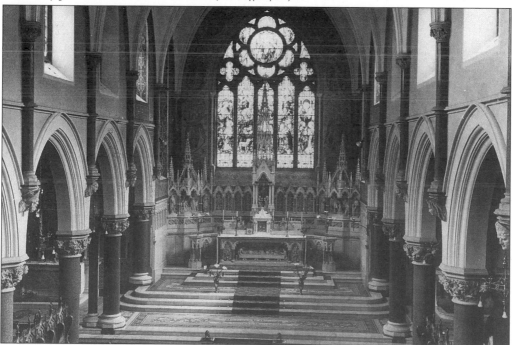

Sanctuary of the chapel of the Good Shepherd convent, now the Good Shepherd church, Ormeau Road. The Carrara marble altars did not reach Belfast for more than a year after the chapel had been brought into use in 1917. The main altar survived a bomb attack and a fire on the ship bringing it from Italy. The central panel is a representation of the Last Supper. (Photograph by J. Moreland FBIPP)

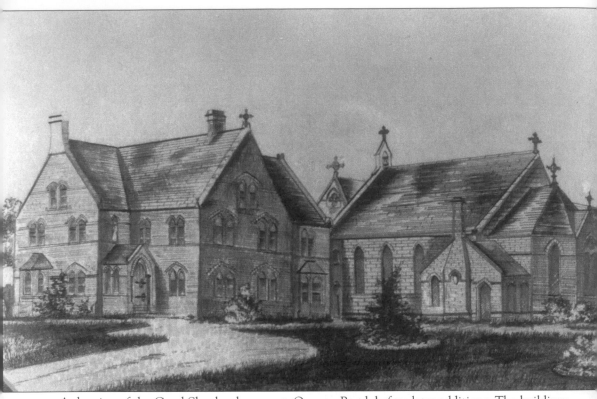

A drawing of the Good Shepherd convent, Ormeau Road, before later additions. The buildings are, from the left: the convent (1869), a chapel (1879), the Catholic Refuge (1868-69). The Good Shepherd Sisters, invited to Belfast to manage a refuge, came to Ballynafeigh in 1868 after their first house, Bankmore, was found to be unhealthy. Land was leased from a Mr Carolan, after whom a nearby street has been named. The growth of the convent's work led to new buildings being added: a new convent was built from 1906 to 1911 and the old chapel was demolished and replaced between 1914 and 1917. The convent opened the first steam laundry in Belfast in 1893 to provide employment for the inmates of the refuge. The former convent buildings now house the Good Shepherd Centre (providing family ministry, marriage guidance, etc.).

The synagogue in Great Victoria Street, designed in 1871 by architect Francis Stirrat. The complex included the minister's house and a Hebrew school as well as the synagogue. It is estimated that there would have been a congregation of around seventy at this time; the Belfast Jewish population peaked at 1,600 in 1960. The building subsequently became an Orange Hall and an Apostolic church. It was demolished during recent redevelopment of the area. (From a painting by Mrs Una Lantin)

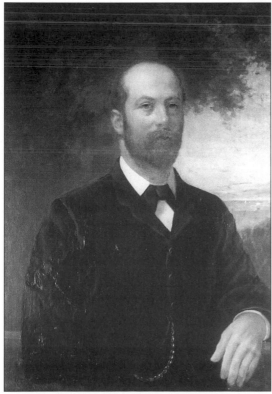

Otto Jaffe, son of Daniel Joseph Jaffe, of Jaffe Bros linen manufacturers, bleachers and merchants of Bedford Street and later of Donegall Square South, was a prominent member of the Belfast Jewish community and a leading figure in local government, serving as lord mayor of Belfast in 1899 and 1904. He was knighted in 1900. The city owed much to both men. Daniel was commemorated by the Jaffe Memorial Fountain formerly in Victoria Square and now standing forlornly in Botanic Gardens. Sir Otto's name was given to the Jaffe School, Cliftonville Road. The school was burnt out by terrorists and is now accommodated at Deramore School, Annadale.

101

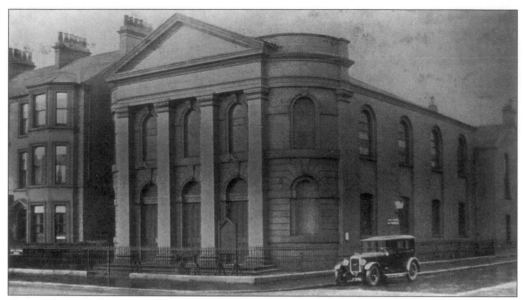

Great Victoria Street Presbyterian church, originally known as Sandy Row Presbyterian church, was built in 1860-61. It continued the Presbyterian tradition of building in the Classical style. The architect may have been John Boyd. The work of the Presbyterian Church in the Sandy Row area began in 1856; various temporary premises were used by the small congregation, including No. 128 Sandy Row. When the first minister, the Revd Robert Montgomery, was ordained in 1860 about forty families claimed membership of the new church. Montgomery spent his entire ministry of forty years in the Great Victoria Street church and died in 1897. A school on Donegall Pass was named after him. The manse was added in 1862 and the schoolhouse to the rear of the church, by William Batt, in 1868.

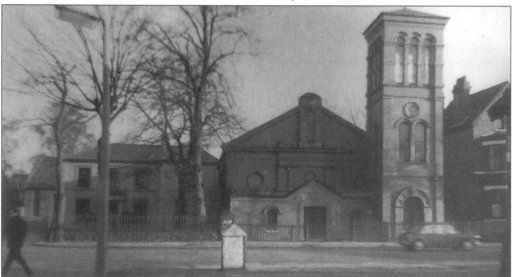

Newtownbreda Presbyterian church and manse, Ormeau Road. The church, built in 1843-44 (the tower was added later), served as a lecture hall after St John's was opened in 1892. When the Revd Robert Workman moved into the manse in 1862 he was struck by 'the extraordinary stillness' of the area. Knockbreda parishioners worshipped here in 1910 while renovations were carried out at their church. The site of the church and manse is now a car park.

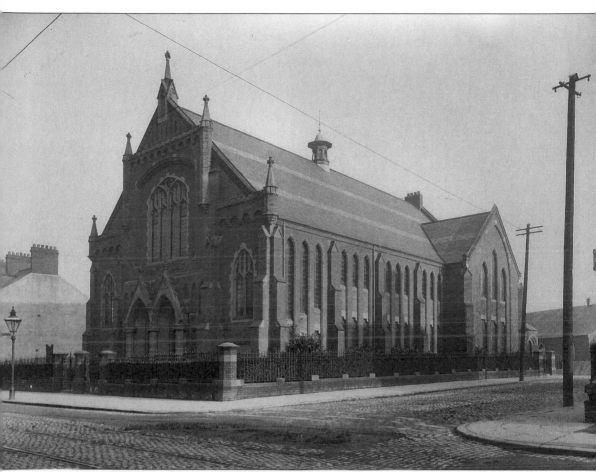

Ravenhill Presbyterian church, which opened on 4 June 1905, post-dates the formation of the congregation that met first in November 1897 in the Boyd Endowment School, Ravenhill Road. In May 1898 it began worshipping in an 'iron church' erected at London Road/Ravenhill Avenue (on the right of the picture). The first minister, John Ross, was ordained on 16 June 1898 and retired aged seventy-eight in March 1944. (I.T. Jess) (By permission of the Ulster Folk and Transport Museum, WAG3259)

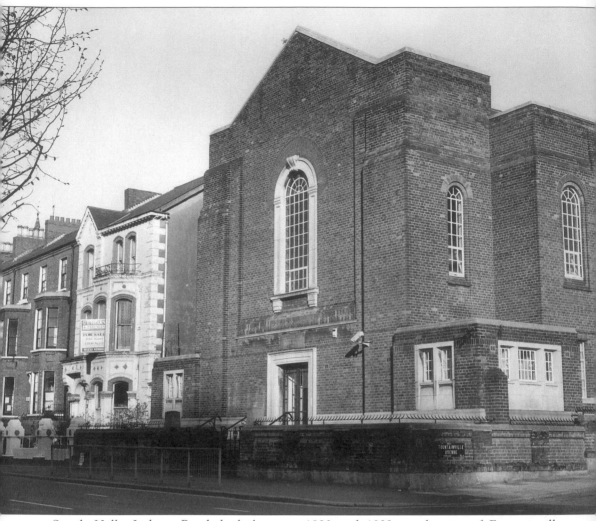

Smyth Halls, Lisburn Road, built between 1930 and 1933 on the site of Fountainville Presbyterian church which had been destroyed by fire in 1920. (Following the fire the Fountainville congregation united with Donegall Road to form Richview church.) The architect was John McGeagh. Beside the hall is the former Fountainville manse by James Mackinnon, built in 1880. (Photograph by Herbie Scott)

Elmwood Presbyterian church, now Elmwood Hall. It was built by Henry Martin in 1859-62 to a design by John Corry, a director of the family firm of contractors and ship-owners. The church, in 'Lombardo-Venetian' style, is richly decorated both outside and inside. The spire was completed in 1873. The former church now belongs to Queen's University and provides a home for the Ulster Orchestra.

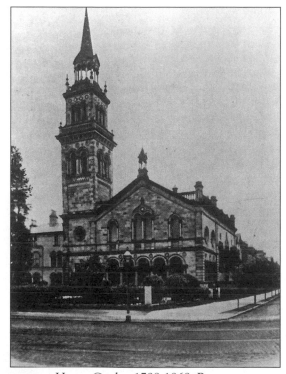

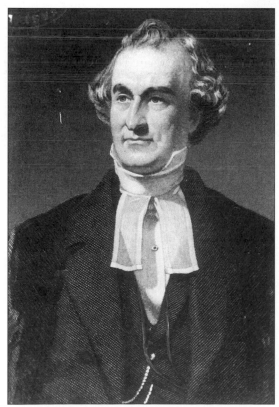

Henry Cooke, 1788-1868. Born at Grillagh near Maghera, County Londonderry, Cooke was educated at Glasgow University and Trinity College, Dublin. In 1818 he was called to the First Killyleagh Presbyterian church, but it is as minister of May Street congregation, Belfast, that he is best known. A powerful orator in an age of great public speakers, Dr Cooke (he held honorary doctorates from Jefferson College, USA, and Trinity College, Dublin) played a leading role in the major disputes of his day: opposition to Arianism in the Presbyterian Church; the new system for Irish national education; O'Connell's Repeal Movement; disestablishment of the Church of Ireland. He was involved in setting up the Free Church of Scotland. Honours bestowed upon him included the moderatorship of the Presbyterian Church (1841 and 1862), presidency of the Belfast Theological College and the freedom of the city of Dublin. A commemorative statue of Cooke – The Black Man – stands in Fisherwick Place. He is buried in Balmoral cemetery. (Courtesy of the *Belfast Telegraph*)

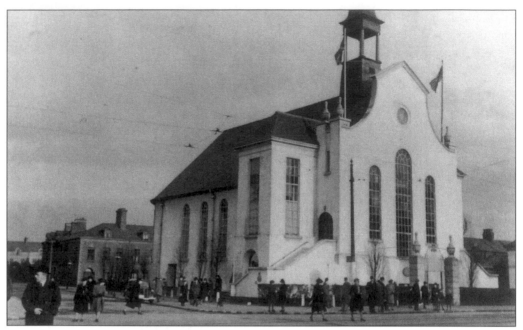

First church of Christ, Scientist, University Avenue. The main building was erected in 1936-37 and dedicated on the clearance of all building costs in 1944. The architect of this fine neo-Georgian building was the distinguished architect Clough Williams Ellis. The complex includes a school (1923) and house (1928).

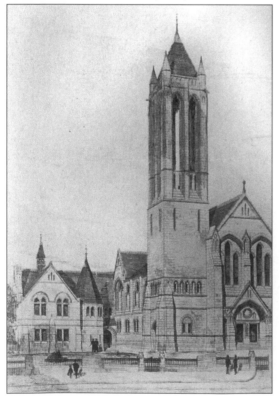

Crescent Presbyterian church, built in 1885-87 by J.B. Wilson of Glasgow. The connoisseur of church towers will be amply rewarded by a walk along University Road where Elmwood, University Road Methodist and Crescent churches offer three different specimens. The Crescent must surely have one of the most striking bell-towers in Belfast.

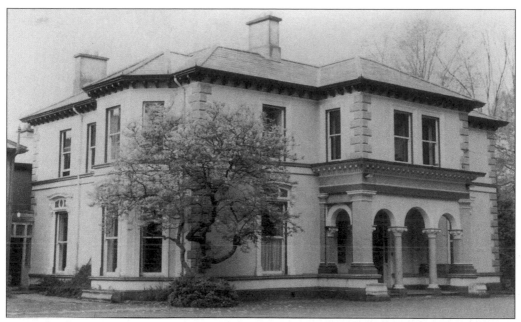

Edgehill Theological College, Lennoxvale. When the Methodist College came into being in 1868 a wing was set aside 'to receive students in training for the ministry'. This arrangement continued until 1919 when Edgehill was purchased by the Methodist Church; the college and Edgehill were separated in 1928. Edgehill was recognized by Queen's University as a constituent college of the Faculty of Theology in 1951.

University Road Methodist church, designed in 1864-65 by architect W. J. Barre. Churches in the University Road area display a fine variety of architectural styles: University Road Methodist church has been described as Lombardo-Romanesque. The central rose window was replaced with a different design following bomb damage in 1973.

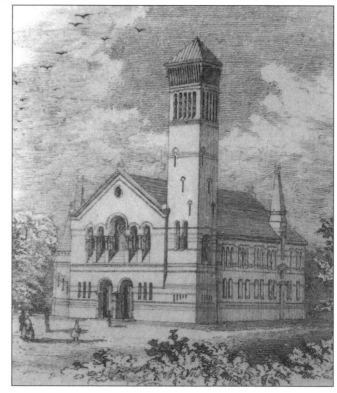

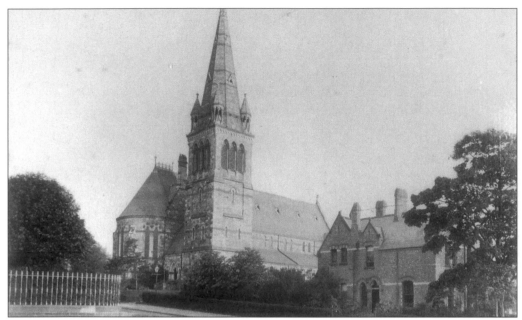

St Thomas' church, Lisburn Road, *c*. 1900. A newspaper reported: 'On Thursday, December 2nd [1870] at 12 o'clock the ceremony of consecrating the new church of St Thomas, Eglantine, Lisburn Road, was performed by the Lord Bishop of Down and Connor and Dromore in the presence of a large and respectable congregation. This church, which is situated in the suburbs [see map on p. 2], is intended to supply the long felt want of increased church accommodation in the south-west district of the town.' The architect was John Lanyon.

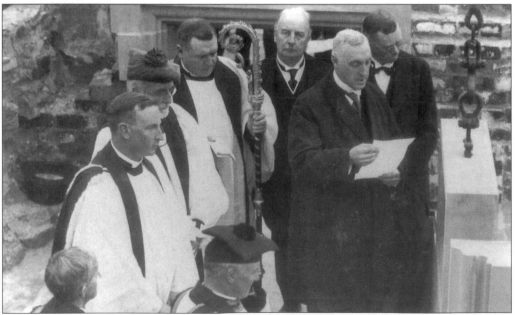

Sir Robert Ewart, Bt, laying the foundation stone at St Polycarp's church, Lisburn Road, in 1930. Housing development in the Finaghy area was answered by the building of churches, for example St Polycarp's (consecrated 1932, architects Blackwood and Jury) and Lowe Memorial Presbyterian church (built 1933-34, architects Tulloch and Fitzsimons).

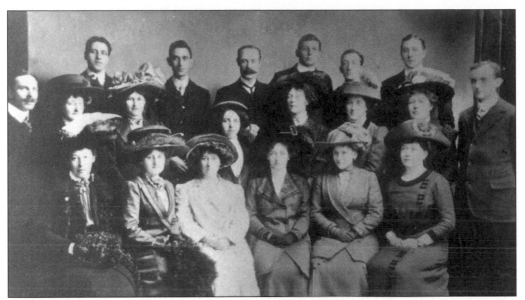
Members of the choir of St Thomas's church, *c.* 1911.

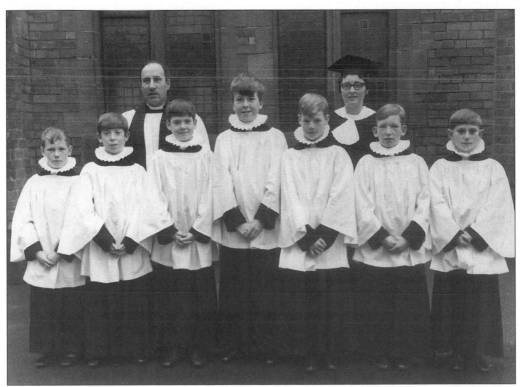
Enrolment of choirboys at St Mary Magdalene church, Donegall Pass, 1968. Choir robes, according to one commentator, had the advantages of 'adding not only uniformity, desirable in itself, but also an indefinable reverence and dignity to the public worship of God.' Compare this photograph with the variety displayed by the choir of St Thomas's church in 1911.

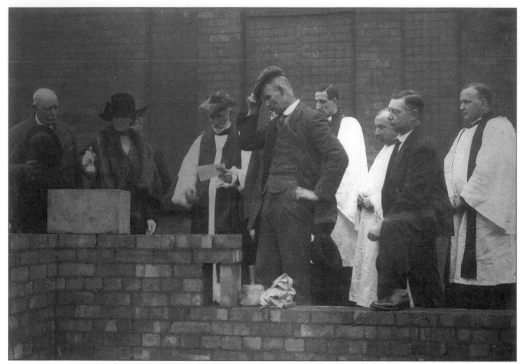

Laying the foundation stone of St Mary Magdalene church hall, Donegall Pass, 1 December 1923. In the background, centre, is the Bishop of Down, Connor and Dromore, Dr C.T.P. Grierson. The new hall replaced the building at Shaftesbury Square (see p. 94).

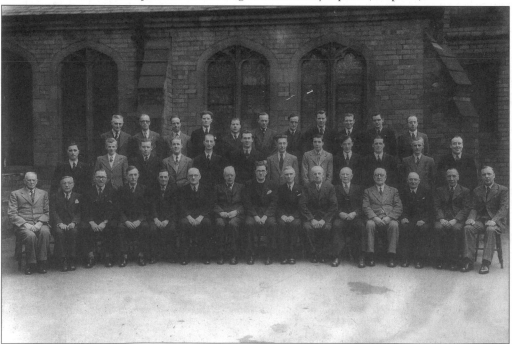

First BB Old Boys' Association Bible class (St Mary Magdalene church, Donegall Pass), session 1949/50. Seated centre is the Revd R. Clayton Stevenson, curate, later archdeacon, of Connor.

Wartime

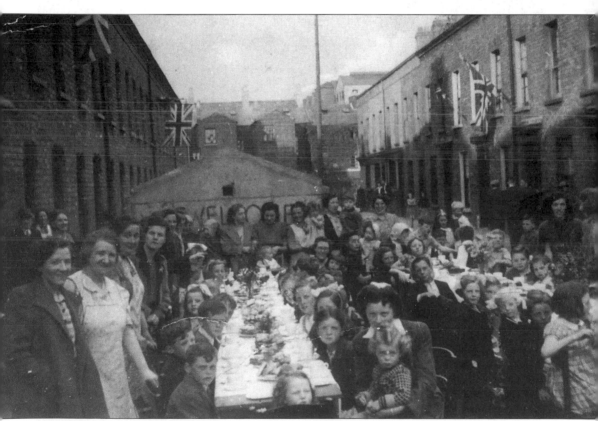

Street parties celebrated the ending of hostilities in 1945. This one took place in Walnut Place, Donegall Pass. The air-raid shelter has provided a surface on which to show the street's sentiments in anticipation of the return of a neighbour, Jim McIntosh, from a Japanese prison camp.

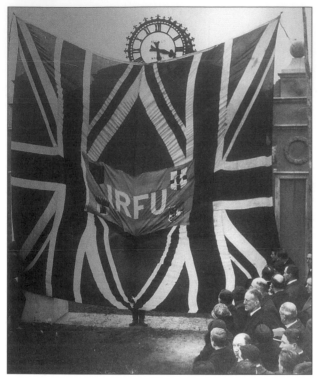

Unveiling at Ravenhill of the memorial to Ulster rugby players killed in the First World War, 22 January 1926. Those present included officials of the three branches of IRFU, and the French team which Ireland would defeat 11-0 in the next day's match. The unveiling was carried out by Mr F.J. Strain, president of the IRFU. The original intention had been to commemorate all Irish players killed in the war with a memorial at Lansdowne Road, Dublin, but the opening of the new ground at Ravenhill had made the Ulstermen determined to have their own memorial. Buglers of 1st Battalion Durham Light Infantry sounded the *Last Post* and *Reveille*. A member of the French team laid the first wreath.

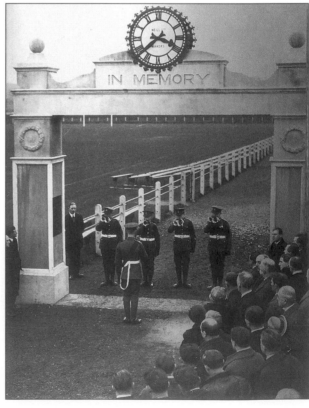

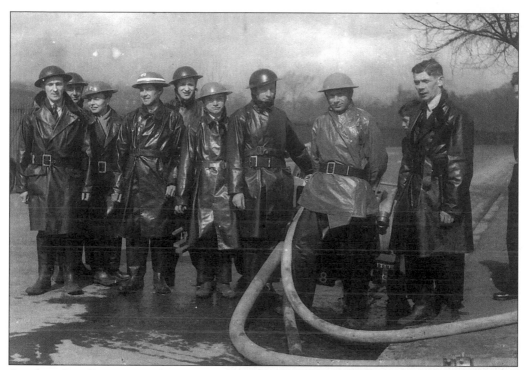

Auxiliary Fire Service unit during the Second World War. On 15 April 1941 the unit based at the Ranger Hall, Malone Avenue, now Belfast Spiritualist church, was called to the LMS railway terminus in York Road. As they drove past the *Belfast Telegraph* office a bomb killed two of the men (George Spence and Hugh Castles) and badly injured the other three. In spite of their injuries Mr Lee and Mr Rainey continued with their fire-fighting and were subsequently commended for their bravery. Over 700 were killed that night and nearly 1,600 injured: it is estimated that 100 bombers took part in the raid. From left: Leading Fireman Clyde Rainey, Fireman George Spence, Jim Lee, Danny O'Kane, -?-, Hugh Castles, Johnny Byrne.

Commendation awarded to Fireman James Lee in recognition of his gallant conduct on 15 April 1941.

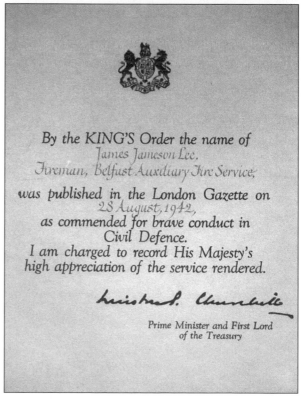

By the KING'S Order the name of
James Jameson Lee,
Fireman, Belfast Auxiliary Fire Service,

was published in the London Gazette on
28 August, 1942,
as commended for brave conduct in
Civil Defence.
I am charged to record His Majesty's
high appreciation of the service rendered.

Winston S. Churchill

Prime Minister and First Lord
of the Treasury

Dr R.H. (Dickey) Hunter saw service in the First World War as a stretcher bearer and lived in Paris for a number of years before taking up the study of medicine at Queen's where he graduated as MB in 1920 at the age of thirty-eight. He was appointed a lecturer in Anatomy in 1924. From 1937 to 1948 he was secretary to the University. During the Second World War the quadrangle at Queen's was ploughed up and plots allocated in a 'Dig for Victory' campaign. Hunter donated a silver cup to be awarded to the grower of the best crop. He invariably won because, being in charge of the allocation of plots, he gave himself a double allowance of the sunniest ground. A colourful figure, he involved himself in the running of the annual Belfast circus, acting as ringmaster. He toured the continent during the summer in search of artistes.

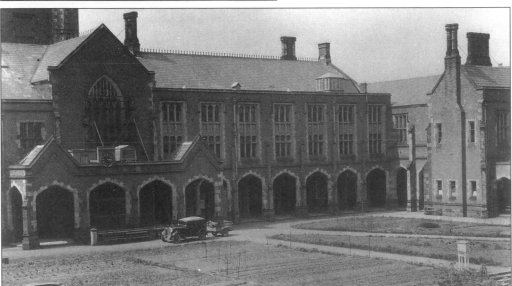

The quadrangle at Queen's University transformed by the 'Dig for Victory' campaign during the Second World War. (The lawns at the front of the Lanyon Building were similarly treated.) All grades of staff could apply for plots: a leading 'taker' was University Secretary Dickie Hunter (who had a double ration); others were Professors Estyn Evans and Newark. Builders' rubble dating from 1848 buried below the turf hampered the operation to start with, as did the absence of worms to aerate the soil.

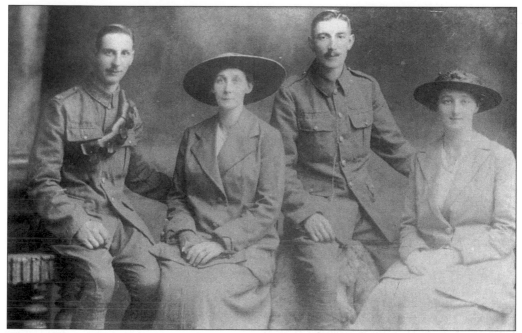

The wartime wedding of Robert and Jane Carslake at St Jude's church, 1917. Marriage acquired a greater than usual solemnity because of the mortality rate among soldiers serving at the front; this is perhaps reflected in the expressions on the faces of the four. Happily Jane kept her man: Robert survived the war. He was employed as caretaker of St Jude's church hall in 1943.

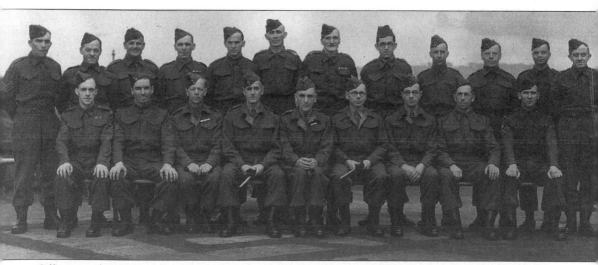

Officers and NCOs of the Home Guard attached to Ormeau Bakery during the Second World War. Two command posts were constructed, one on the pavement outside the bakery, the other on the Annadale Embankment, to protect the area from attack. The men, in co-operation with members of the ARP, did two-hour shifts each night. James McCaw (centre, front), sales director of Ormeau Bakeries, who had served in the First World War, was appointed captain. Training was provided by the Irish Guards; in addition, the company drilled two nights a week, with the occasional Saturday or Sunday thrown in for good measure. The rifles were from the Boer War. The men were expected to do a normal day's work in addition to guard duty.

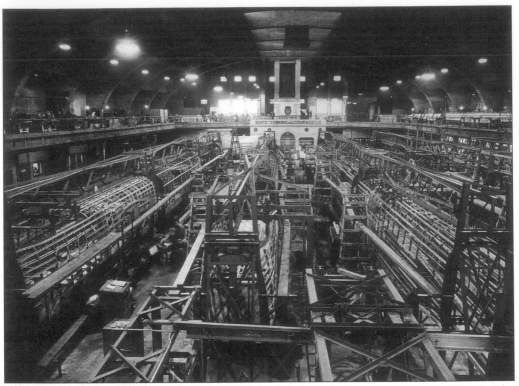

The King's Hall in wartime, 1939-45. The main premises at Balmoral became an Air Ministry factory where Short Bros and Harland built chassis for Short's Stirling bombers. Other wartime users included an American field bakery unit (jumping enclosure) and the Auxiliary Fire Service (equipment store in the implements shed). The society made some gains from this wartime use: extended sewers and some new buildings were installed.

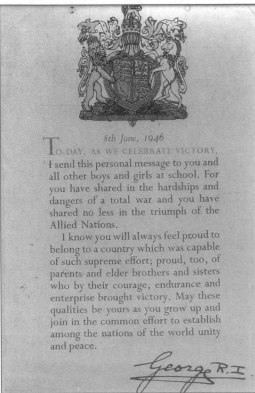

8th June, 1946

To-day, as we celebrate victory, I send this personal message to you and all other boys and girls at school. For you have shared in the hardships and dangers of a total war and you have shared no less in the triumph of the Allied Nations.

I know you will always feel proud to belong to a country which was capable of such supreme effort; proud, too, of parents and elder brothers and sisters who by their courage, endurance and enterprise brought victory. May these qualities be yours as you grow up and join in the common effort to establish among the nations of the world unity and peace.

George R.I

Victory certificate given to all schoolchildren to mark the end of the Second World War. Children had made their contribution to winning the war by, for example, collecting books for waste paper; they were rewarded with badges giving them military ranks according to the number of books brought in.

Eight
Sport and Recreation

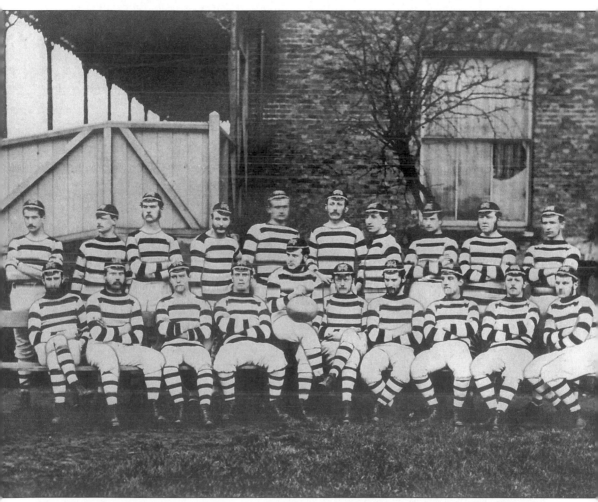

The first Irish international rugby team, 1875. The team of twenty included six players from the North of Ireland Cricket and Football Club. The (rugby) football section of North was formed in 1868 at a time when it was reckoned that rugby was almost entirely unknown in Ireland: sons of the gentry learnt the game through being educated in England. The North Players in the 1875 match, played at the Oval in London and resulting in an English victory by two goals and a try to nil, were: back row: G. Andrews (seventh from left), W. Ash (ninth from left); front row: E. McIlwaine (first left), R. Walkington (eighth from left), R. Bell (ninth from left), F.A. Combe (tenth from left). The team captain, G. Stack (centre, front row), died a year later in tragic circumstances.

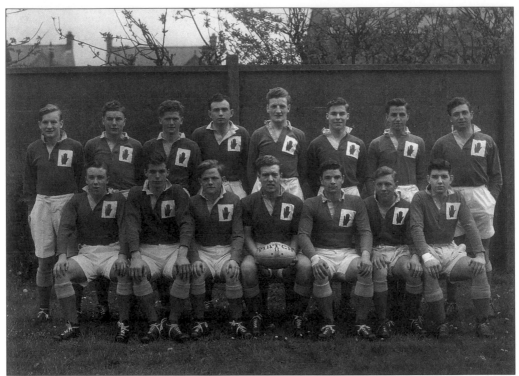

Ulster Schoolboys' XV which defeated an Anglo-Welsh Schoolboys' XV by three tries to nil at Ravenhill on 20 April 1949. R.G.S. McNutt, Methodist College, was the Ulster captain.

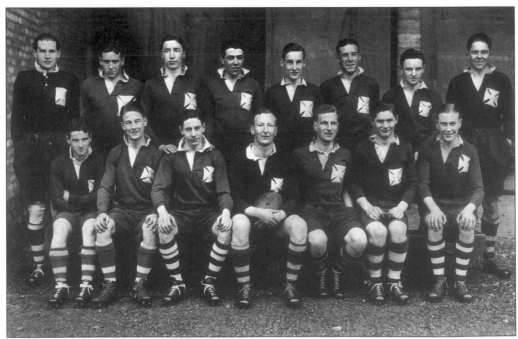

The Methodist College 1st XV were defeated by eight points to nil by RBAI in the final of the Schools' Cup at Ravenhill in 1933.

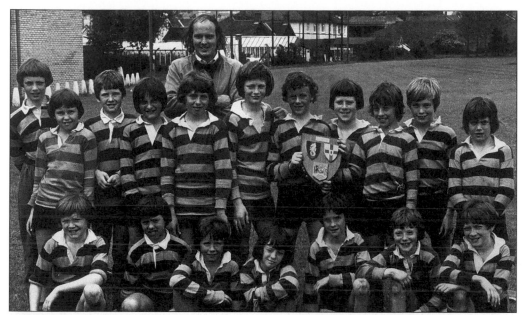

Inchmarlo rugby team, 1960s. Are there any future Schools' Cup players here?

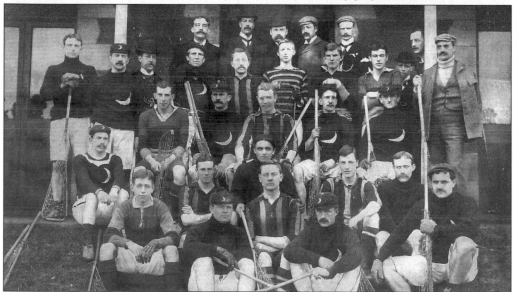

The Northern Irish Lacrosse Club defeated Crescent Lacrosse Club from Brooklyn, USA, at Ormeau on 29 April 1879; the score was 4-2. Tours by Canadian teams in 1876 inspired a number of clubs to take up lacrosse. Between 1881 and 1903 Ireland met England in twenty-two internationals, winning twelve; there were four 'North' players in the 1881 side. Lacrosse, played in late spring, was forced to give way to both kinds of football, whose important matches were played in March and early April. From 1912 the shadow of Home Rule for Ireland loomed and Unionists prepared to resist. The East and South Belfast County Committees of the Ulster Volunteer Force drilled at 'North' and all matches were cancelled from 1 January 1914 to allow members identified with the UVF and Unionists' Clubs to prepare for 'eventualities'. In August 1914 a greater struggle began and many men who had trained at Ormeau found themselves fighting in France.

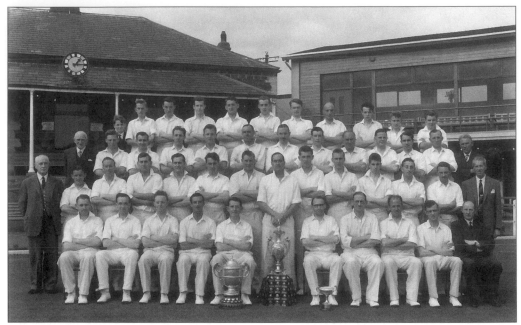

North of Ireland Cricket Club, winners of the Senior Challenge Cup (1st XI) and Second Division League, Section F (3rd XI), 1960. The club was formed at a meeting in the Royal Hotel on 29 November 1859 and played its first season in 1860 with a full local programme of matches, games against the All-Ireland and All-England XIs and an English tour. The Club has sold its Ormeau Road ground and is moving to Orangefield.

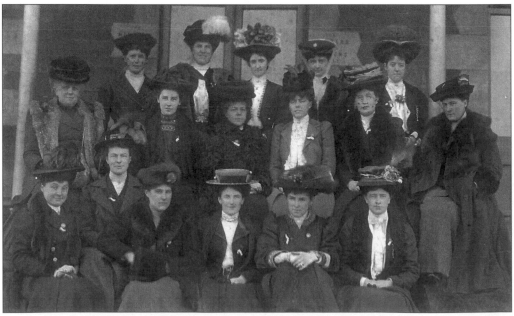

North of Ireland Cricket and Football Club ladies' committee, c. 1890. The ladies provided hospitality for visiting teams at North fixtures and raised money for charity.

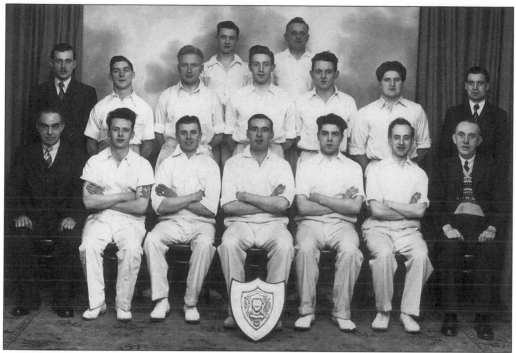

Laganbank Cricket Club was formed around 1944 by Joe McMullan (first right at the front), from members of Belfast Electricity Department's cookers section. Members paid sixpence a week to Club funds and played in Ormeau Park. They seemed a most unlikely lot to win a competition: Mr Hull, third from left at the front, remembers that 'the only one with a clue' was Billy Bradford, the captain (centre, at the front), and he was a footballer, playing in his time for Glentoran and Belfast Celtic. But win they did, defeating Woodvale in the final of the Ulster Junior Shield in 1949. They had to borrow the whites for the photograph!

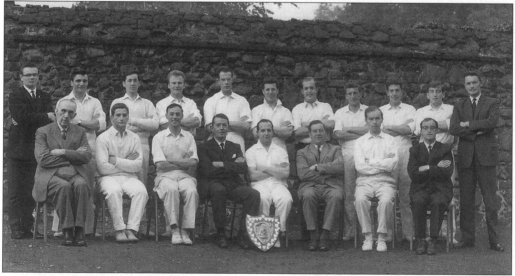

Laganbank Cricket Club, winners of the Ulster Junior Shield, 1964. In the 1950s players were drawn from a wider circle than BCED. The club continued to play through the sixties; stumps were drawn for the last time about 1970.

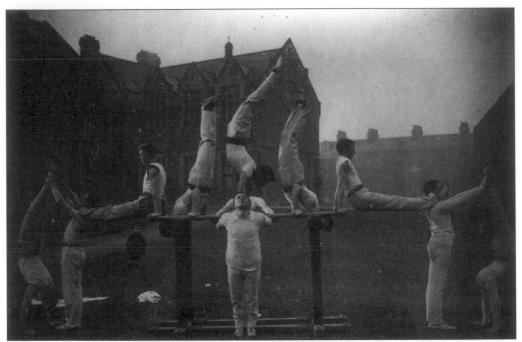

Gymnastics at Queen's College, *c.* 1900. A small boy watches with interest. The old medical building to the left has been replaced by the new Administration block.

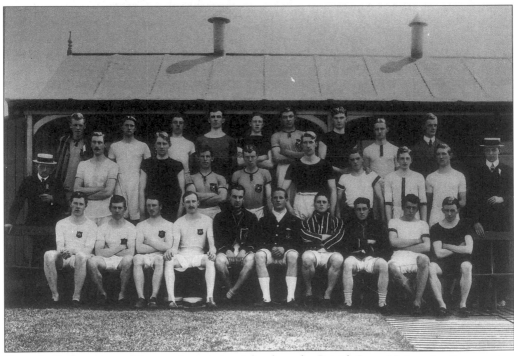

Queen's College proved its sporting credentials when the British Inter-University Sports came to Belfast in 1908. The four athletes on the left were Queen's men. The others represented Cork, Dublin, Liverpool, Leeds, London and Birmingham.

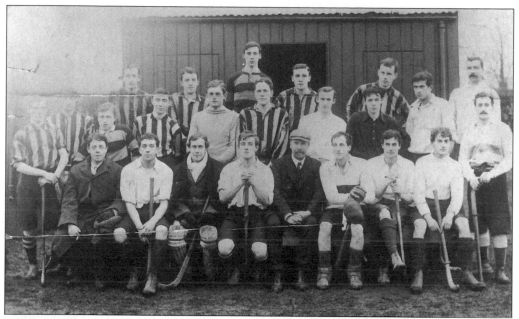

Queen's College men's hockey team, c. 1904/05. Are those the changing facilities in the background?

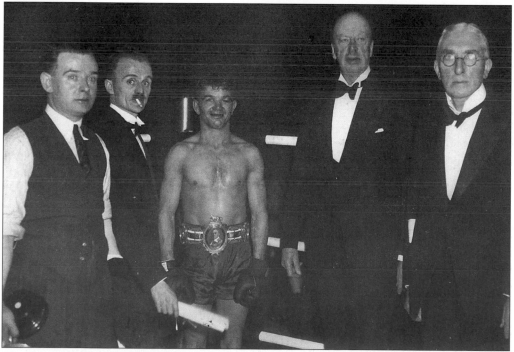

The King's Hall has been the venue for pop concerts, circuses, religious crusades, exhibitions, boxing and wrestling. Fans packed in to cheer on champions such as Rinty Monaghan, Billy Kelly (pictured, in 1954), Freddie Gilroy and Barry McGuigan. When local hero Jimmy Warnock was down for a count of six in the second round of a fight in 1935 someone came to the rescue by switching off the lights!

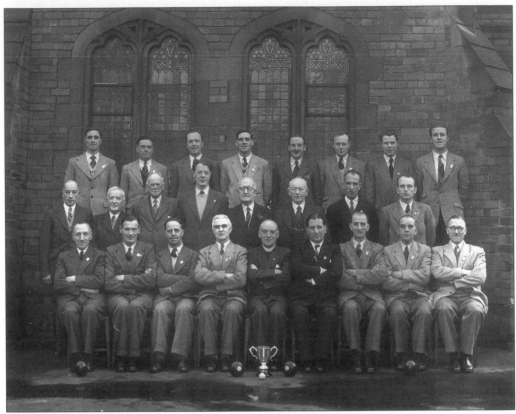

Members of 1st BB Old Boys' Bowling Club (St Mary Magdalene church) and associates pictured with the rector, the Revd W. J. R. Benson, at the end of a successful season in the early 1950s.

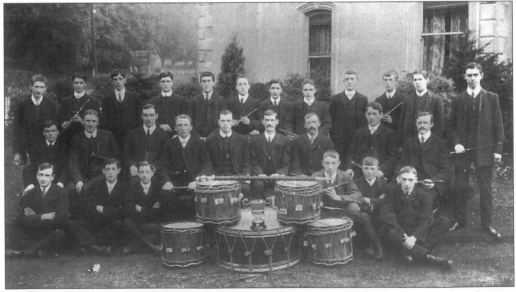

Deramore Flute Band, which can be seen taking part in the Orange procession leaving Ballynafeigh Orange Hall on p. 39. The band won the Wolff Challenge Cup in 1908.

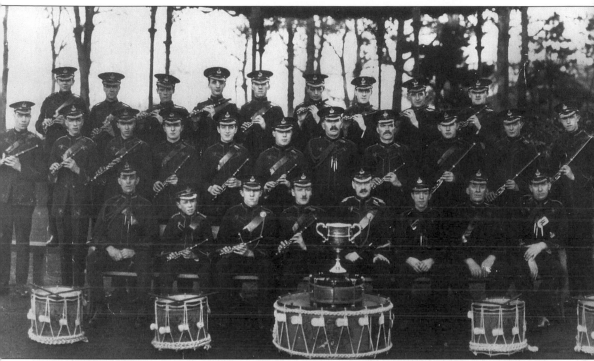

Ormeau Flute Band, winners of the Northern Ireland Bands' Association championship, *c.* 1928. James 'Pop' Bell formed the band in around 1920 in a small band room in Cooke Street. The band later built the Imperial Hall at Havelock Place, where the UTV car park now is. The hall was rented out for social events to help cover costs.

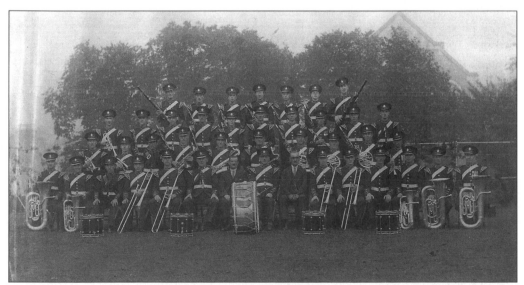

Ormeau Military Band. In 1934, Ormeau Flute Band was upgraded to military status. James Bell continued as conductor, holding the position until his death some fourteen years later. The band is still in existence and now meets in Glenburn Methodist church hall.

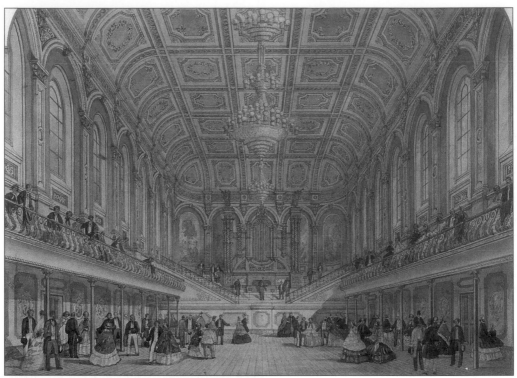

William J. Barre's original design for the interior of the Ulster Hall. Barre, a young architect from Newry, won the competition to design the Hall, built between 1859 and 1862. For reasons of economy the full splendour of Barre's scheme was not carried out. The organ was presented by Andrew Mulholland in 1862. (By permission of Ulster Museum, 10/4B/Ulster)

James Young was Ulster's star comic during the sixties and early seventies. A discovery of Sir Tyrone Guthrie's, Young developed his talents at the Ulster Group Theatre, on radio (as Derek the window cleaner in *The McCooeys*), on television (creating characters such as Mrs O'Condriac, the Cherry Valley Woman and Orange Lily) and on tour in Canada and the United States. The Troubles distressed him: he often finished a television show with an urgent 'Stap fightin''. Born in Fernwood Street, off the Ormeau Road, where a plaque marks the house, he died in 1974. (Photograph by Stanley Matchett FRPS)

The Apollo cinema, Ormeau Road, opened in 1934. The 'pictures' offered many Belfast people an escape from the grimness of daily life. South Belfast was well supplied with cinemas; today only the Curzon on the Ormeau Road remains. The Apollo closed in 1963, like the others a victim of television. (Photograph by Janet Hearle)

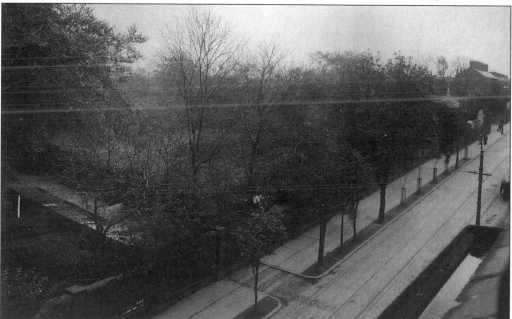

The site of the Ulster Museum, Stranmillis Road, in 1913. A competition was announced in 1913 for designs for a museum and art gallery. The winner was J.C. Wynnes of Edinburgh. The First World War meant that building had to be postponed and when the Museum was built between 1924 and 1929 Wynne's design was amended and the building left incomplete. An extension in a modernist style was added between 1963 and 1971. At the top right of the picture is the lodge at Friar's Bush graveyard. (By permission of Ulster Museum, H/79/30)

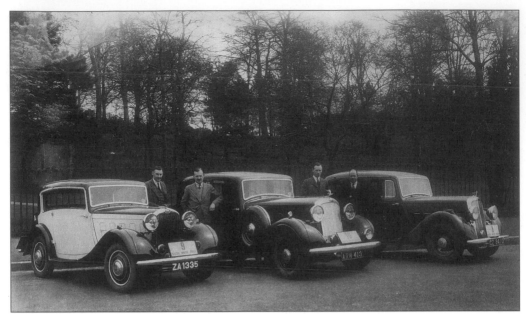

The Humber team (from left, a Vogue and two Snipes), awarded third prize in the 1935 Ulster Motor Rally organized by the Ulster Automobile Club. It was the first to be held during the Easter weekend, now the traditional Circuit of Ireland time. Car number 8 was entered by Mr Charles Hurst, then the main Northern Ireland Humber dealer. This was the last Ulster Motor Rally before the introduction of the Circuit of Ireland in 1936 and covered a course of 500 miles, finishing in Bangor on 23 April 1935. (By permission of Ulster Museum, H 10/60/33)

How better to spend a pleasant summer day than to take a tram to the Malone terminus, walk a short distance and enjoy afternoon tea at the Dub Tea Rooms? This picture dates from around 1910. (By permission of Ulster Museum, H 10/81/2)